MY ART WORLD

Recollections and Other Writings

JOHN SEED

Independently published via Amazon Kindle Direct Publishing Services, April 27, 2019.

Copyright © 2019 by John Seed

email: johnseed@gmail.com

All rights reserved.

No part of this book may be reproduced in any form or by any electronic or mechanical means, including information storage and retrieval systems, without written permission from the author, except for the use of brief quotations in a book review.

ISBN-10: 1095997920

ISBN-13: 978-1095997925

ASIN: B07R6B6LZ4 (ebook)

❦ Created with Vellum

CONTENTS

Foreword	v
1. Nathan Oliveira: A Mentor and a Friend	1
2. Hunk and Moo Anderson: Passions Cannot Be Denied	3
3. A David Park Drawing: A Gift	8
4. Frank Lobdell: "Nothing Worth Anything Is Easy"	13
5. My Visit with Richard Diebenkorn	20
6. A Critical Piece of Advice Robert De Niro Senior Gave Me About Art	27
7. Mazurki: The Multiple Meanings of a Philip Guston Drawing	31
8. Joan Brown: Towards Unexpected Joy	39
9. Working for Larry Gagosian (1982-83)	45
10. The Angry One: Jean Michel Basquiat	56
11. MOCA Memories: 1983-85	64
12. F. Scott Hess: A Contemporary Realist	75
13. Nathan Oliveira: Forgetting the Self	79
14. Masks and Other Spectral Presences: Prints by Nathan Oliveira, 1952 – 1972	88
15. "Basel Mural I" by Sam Francis: An Artist at the Height of His Powers	94
16. Richard Diebenkorn: The Berkeley Years (1953-66)	99
17. The Other End of the Stick: Richard Diebenkorn's Ocean Park Series	104
18. Saying "Goodbye" to Diebenkorn	109
19. When Art Likes You Back	114
20. Contemporary Art ™ is a Now a 'Brand'	118
21. Is Having an 'Eye' for Art a Thing of the Past?	121
22. A Brief Rant on the Exhaustion of the Avant-Garde	125
23. So These Three Artists Walk Into a Jeff Koons Show: Some Thoughts on Art and Skill	131
24. Hell Has Frozen Over: Figurative Art Is Poised to Become the 'Next Big Thing'	138
25. On Art and Empathy	142

26. Bo Bartlett: The Intermediary — 147
27. Margaret Bowland: They Say It's Wonderful — 153
28. Kerry James Marshall: "Mastry" at MOCA — 161

 About the Author — 165
 Also by John Seed — 167

FOREWORD

In the painting studio at Stanford University, 1978

The various writings that open this book reflect a habit of mine: I often use anecdotes from my own life and experience as starting points. When I began writing about art and artists for the Huffington Post in 2010, memories provided starting points for many blogs. As I now understand, writing had become my personal tool for making sense of the people and experiences that had shaped me. I never had

the intention of writing a memoir, but many bits and pieces of one poured out of me at different times in different contexts. In this book, I have tried for the first time to weave these together into a kind of word collage.

Most of the recollections and essays in this book have been previously published, either on my personal website—in the HuffingtonPost or Hyperallergic—or in the form of magazine articles. In the process of assembling, re-reading and editing them, I have tried to make sense of my own memories and formative experiences, and in doing so, offered a context for my gradually maturing tastes. Slight changes have been made to reflect changes in my views over time, and to make these writings come together.

Although there are some gaps in my memories, I have tried hard to be fair and accurate. When I first published a blog about my encounters with Jean-Michel Basquiat, I worried that I had been too blunt. Then, an out of the blue e-mail from Jean's former girlfriend, Suzanne Mallouk re-assured me. "I love your insights," she wrote. "You really captured him in your piece." That was encouraging. In writing about the art dealer Larry Gagosian—an almost impossibly intense character—I tried to find the right balance between judgment and humor.

Some of my recollections are substantial, while others revolve around very slight encounters. When this was the case—as with Joan Brown or Frank Lobdell—writing a profile was my way of understanding someone from my past in a more complete way. My profile of the collectors Hunk and Moo Anderson is more formal than some others, and that is out of respect. Richard Diebenkorn, who I met in 1978, is the subject of a recollection and three essays, so he gets the "most written about" prize.

Two of the recollections concern works of art that I once owned. By writing about them, almost as if they were people, I hope to show how those works—and the artists behind them—challenged and inspired me through their art. Finding the human being behind each work of art is one of my preoccupations.

Towards the end of this collection are a series of essays that represent my more mature reflections on the problems of art in our contemporary world. They were generally written 25 or 30 years after the

formative events mentioned in my recollections; and I will leave it up to the reader to discern just how my early encounters and adventures coalesced into views and complaints that animate my later writings.

Finally, I present interviews with two artists I think highly of—Margaret Bowland and Bo Bartlett—before concluding with an appreciative review of Kerry James Marshall's recent retrospective. These three pieces are here to offer an idea about the current art and artists I have come to respect.

I hope you will genuinely enjoy these writings and that they will open up many conversations. These recollections and writings memorialize my growth—an ongoing process—and also reflect the both the challenges that my immersion in art has fostered. The parallel universe I call "My Art World" is a place of memories images and ideas. It's my great pleasure to share them with you.

- John Seed

NATHAN OLIVEIRA: A MENTOR AND A FRIEND

John Seed and Nathan Oliveira, 1978

When I walked into Nate Oliveira's Monoprint class in my sophomore year, I had no idea I was walking straight into my future. Unlike so many of my friends, my major was "undecided." To put it kindly, I was intellectually immature and lacked direction. Professor Oliveira was about to change that.

Teaching, at its best, is about transforming the way students think, and Oliveira changed my thinking forever by introducing me to a process-oriented way of problem solving. Monoprint is a printmaking method in which a quick painting is brushed, smudged, and wiped onto a zinc plate then pressed onto wet paper with an etching press.

Although each image is unique, a faint "ghost" image remains after each impression. Oliveira encouraged us to treat each such image as the starting point for another print. I sat slack-jawed while he gave a slide show of his *Tauromaquia* monoprints, a seemingly endless series of themes and variations inspired by Goya. Oliveira's way of thinking was so stunningly flexible and inventive. A door was opening for me.

By the end of the semester, I had become obsessed with monoprint. When I wasn't busy covering zinc plates with oily black etching ink, I was waiting on the bench in front of Oliveira's office, ready to show him my latest work and bombard him with questions. As I explored the monoprint process, my curiosity grew, and I found myself improving as a student in all areas.

Nathan not only patiently answered my questions, he became a true mentor and friend. When my parents visited Stanford, he reassured them that I might indeed have a future as an art major. He invited me to his home, where he and his wife Mona treated me as a guest and showed off the wondrous things they had collected. Sensing that I needed exposure to a larger range of artistic influences, not to mention some pocket money, Nathan prevailed on local art collectors Hunk and Moo Anderson to hire me as an intern.

By junior year, I was spending Saturday mornings at Oliveira's studio in an old theatre on Hamilton Avenue. As a paid assistant, I would stretch 6- and 7-foot-wide canvases and watch the progress of Oliveira's oil paintings. I remember him laughing to find the imprints of my sneakers on the backs of the canvases I had stretched. When work was over, there might be milkshakes at the Peninsula Creamery.

That same year Nathan contacted his friend, the painter Richard Diebenkorn, and arranged for me to meet him in Southern California during Christmas break. When I look back at the connections and opportunities that came my way through Oliveira, I am humbled. He remained an encouraging presence even when I was not taking his courses. Hanging in my office today is a scrap of paper towel I once found on my easel after wrestling with an awkward painting for Frank Lobdell's class. Brushed in dark viridian green oil paint, the message was simple: "Getting Better N.O."

Originally published in Stanford Magazine, November/December 2002

HUNK AND MOO ANDERSON: PASSIONS CANNOT BE DENIED

Moo and Hunk Anderson, 2000

When it was announced on June 14th of 2011 that 121 key works of American art from the Anderson Collection had been donated to Stanford University, I went straight to my office bookshelf. There I found the dog-eared copy of *American Art Since 1900: A Critical History*, by Barbara Rose, that Hunk and Moo Anderson had presented to me in 1979 after my two years of service as an intern to their collection. During those two years I learned what it meant to be surrounded by great art and by collectors who passionately believed in their choices. Visiting the Andersons at their home—where Pollock's *Lucifer* hung in

the dining room along with a Picasso, a de Kooning and a Dubuffet—made indelible impressions on my taste.

Hunk had written an inscription inside the book's cover that included the two essential questions the Andersons had asked themselves constantly during their many years of evaluating, acquiring and living with modern and contemporary art:

1) Have I seen it before?

2) Could I have thought of it?

Those two questions, straightforward and succinct, say quite a bit about Hunk and Moo and how they focused their thinking about modern art over more than four decades of collecting. The Andersons put a high value on innovation, and as a result were able to acquire seminal works of American modern art before they were broadly appreciated and prohibitively priced.

Hunk Anderson liked aphorisms—his friends and family called them "Hunkisms"—and when I spoke to him on the phone in 2011, asking a few questions about the Stanford bequest, he repeated one of his favorites: "I didn't know it couldn't be done, so I just went ahead and did it." That saying describes Anderson's career as an art collector and also his remarkable success in business.

Harry "Hunk" Anderson was one of three founders of Saga Foods, a corporation that started when Hobart College in New York closed its cafeteria in 1948. Anderson and two friends—Bill Laughlin and William Scandling—reopened it and used a clever system of selling meal tickets in advance to finance their operations. As the business grew exponentially into a thriving food-service and restaurant business, the trio developed "The Saga Way," a set of corporate values that mirrored the Golden Rule: "Treat others the way you would like to be treated yourself."

When Saga went public in 1968, the Andersons found themselves with some discretionary funds. Or as Hunk liked to say there was "something left in the vault." Their collecting activities took off after a 1964 visit to the Louvre in Paris, which Hunk remembers as "a life-changing event." In its early stages, the collection included Impressionist works by Monet, Pissarro and Renoir, followed by some American modern works from the 1920s. Their initial vision, as Hunk

remembers it, was that he and Moo "... could put together a collection of maybe a couple of dozen major artworks." Eventually, they assembled what the late Albert Elsen—a professor of Art History at Stanford—called a "collection of collections," numbering more than 1400 works.

"We went to the library, we got catalogs, we saw shows," Anderson remembers. "Moo really almost took a course from Al Elsen and read his book *Purposes of Art*. I would sneak over there [Stanford] too. Albert Elsen was very, very instrumental in the forming our earlier collection."

Elsen used to bring his students to the Anderson home and would spend thirty minutes or more showing the students the Andersons' cast of Rodin's *Walking Man*, running his hands over it as he spoke. Around the same time, Elsen nudged the Andersons to consider possible changes and suggested selling or exchanging early modern works in order to focus the growing collection's identity. Nathan Oliveira, a member of Stanford's studio art faculty, was influential in introducing the Andersons to active Bay Area artists, and praised their acquisition of Bay Area figurative works by Richard Diebenkorn and David Park.

By the mid-70s the collection had grown large enough that it was on display in two locations: at Saga Foods corporate headquarters and in the Andersons' home. Saga employees and visitors who came to see the collection found a Wayne Thiebaud painting of pies in the employee cafeteria, paintings and etchings by Richard Diebenkorn in the hallways and a complete set of Gemini G.E.L. lithographs—the Stoned Moon series by Robert Rauschenberg—in the accounting center.

Many of the key works from the collection, including abstract expressionist paintings by Pollock, de Kooning, Rothko and Kline, were displayed at the Andersons' home. Art historian Barbara Rose recalls very clearly the impression that the house, the collection and the Andersons made on her when she visited in the 1970s:

> *I visited them at their home when I was teaching in California and I was stunned to find that each room had a masterpiece in it and—other than that—*

was relatively empty. The house was simple and unpretentious with no name brand architect competing with the paintings.

Nothing in the house was meant to distract from the art, and each work was treated with the kind of respect that serious art deserves. The collection was focused on quality, not quantity, and it obviously meant a great deal to them. I will never forget that visit. It made me feel that they were genuine collectors who were devoting their lives to learning about, and living with, great art.

The Andersons gained a reputation with dealers for desiring only the best works. Hunk Anderson puts it this way: "The most important thing was being sure that we collected not only the best artists, but their best work. Quality, quality, quality…" When a crate arrived from New York containing a work for the Andersons to consider, it was set among the other works in the collection to see if it made the grade. "They [the works] had to speak to each other," Hunk once told me.

In this remarkable environment, the Andersons raised their daughter Mary Patricia (Putter) who grew up familiar with great works of art. Jackson Pollock's *Lucifer* once hung above her bed, and in the house's entryway stood an early Giacometti sculpture she liked to call "Skinny." Not surprisingly, Putter later played an important role in the family's collecting activities.

During the 80s and 90s the Andersons' acquisitions continued—including key works by Rothenberg and sculptor Martin Puryear—but so did selective selling, so as to focus their collection on art that was "made in America" from the post-war years to the present. Saga headquarters became a corporate office park named Quadrus in 1988, and the public part of the Anderson Collection is still there, available for tours on the 3rd Thursday of every month. Over 650 graphic works, many of which were once on display at Saga, were donated in 1996 to the De Young Museum to establish the "Anderson Graphic Arts Collection."

Over the years, more than 30 undergraduate and graduate students from Stanford and other universities have served as interns to the Anderson Collection, guiding tours and learning about art through close proximity. One of the interns, Neal Benezra, is now the director of the San Francisco Museum of Modern Art which hosted *Modern Art:*

The Anderson Collection in 2000. For that reason, it had long been speculated that key works from the collection would go to SFMOMA, which had already received more than 20 pop works from the Andersons in 1992, 7 Frank Stella paintings in 2002 and also prior gifts of works by Clyfford Still, David Park and others.

Looked at from a broader perspective, the Andersons bequest to Stanford makes a great deal of sense: it is the culmination of a long relationship with Stanford and with other educational institutions including Hobart College and USC.

> *Moo and I have spent our adult lives just on and off of college campuses,"* commented Hunk Anderson. *"One of the things that Stanford is doing is creating an Arts Initiative. President John Hennessy is trying to create the basis for breadth in education, and the integration of disciplines. We feel very proud to be a part of this initiative." The Anderson Collection, which is slated to open in 2014 in a building that is yet to be designed, will stand in close proximity to other buildings in a planned "arts district."*

Paula Kirkeby, an art dealer and a friend of the Andersons, called their donation a "Wonderful and well thought out gift for Stanford." Of course, what Stanford is getting is more than a collection of works of art, but also a kind of cultural and historical record.

According to Rachel Teagle, a former Anderson intern who later served as one of the collection's curators, the Anderson Collection can be seen as a record of American artistic innovation and achievement that runs parallel to the historic rise of American industry in the post-war period. "I think what is so great about the collection," says Teagle, "is that the collection itself is an artifact of Hunk coming of age as a collector after going to school on the GI Bill, and then taking part in an era of industry when America made things. The collection reflects a similar rise to prominence."

The Anderson Collection was created by a forward-looking family that learned about art as they lived with it. Of course, it was about more than education. "We are very much self-taught, "noted Hunk Anderson, "but passions cannot be denied."

Originally published in The Huffington Post, June 23, 2011

A DAVID PARK DRAWING: A GIFT

A David Park wash drawing, circa 1957

I think of painting—in fact all the arts—as a sort of extension of human life. The very same things that we value most, the ideals of humanity, are the properties of the arts.
 - David Park, 1959

. . .

In the spring of 1978 I saw a retrospective of works by David Park (1911-1960) at the Oakland Museum. At the time, I was in my third year of college, a recently declared art major. More than any exhibition I had seen before, or any I have seen since, the Park exhibition spoke to me. Park's art was incredibly direct and honest. He had a way of capturing the humanity and pathos of his human subjects.

I must have said something along those lines in the letter I wrote shortly thereafter to Mrs. Lydia Park Moore, Park's widow, now remarried. She wasn't hard to find: many of the paintings at Oakland were listed as belonging to "Mr. and Mrs. Roy Moore, Santa Barbara, California," and they were listed in the phone book. I don't remember exactly what I wrote, but I certainly did my best to tell Mrs. Moore about what I loved in Park's paintings, and I also asked if there was something small, maybe a drawing, I could purchase.

For the past 32 years the letter she wrote to me in reply has served as my bookmark for the David Park catalog I brought home from Oakland. Written in a clear hand in blue ballpoint on elegant stationary, here is what it says:

May 3, 1978
 Dear John Seed,
 In a day or two I shall send you a "studio drawing" by David Park. A gift, no purchase!
 When I read your letter I was very moved. If an artist, or any human being for that matter, can give another individual encouragement, hope, a desire to believe in his own work, then the whole effort is worthwhile.
 If you are ever in Santa Barbara please come and see us. We have a few paintings here which are not exhibited very often, and you might like to see.
 Sincerely,
 Lydia Park Moore

About a week later a manila envelope arrived at my college PO Box. Mrs. Moore hadn't packed it with any great care, and it came out of the envelope a bit rumpled. When I later mentioned this to Park's daughter, Helen Bigelow, she recalled that her father wasn't too formal about packing art either. "David once mailed me a small oil painting wrapped up in brown paper with string," she recalled.

The top edge of the drawing had been torn out of a spiral drawing pad, the paper was slightly yellowed, and it had no signature. Still, there it was: an original work by David Park, and a rather powerful one.

Park, who is credited with founding the "Bay Area Figurative School," was a painter who felt a strong connection to the human figure. He was something of a rebel in insisting on painting the figure when most American modernists were practicing abstraction.

His late works portray the figure with powerful calligraphic brushstrokes that can verge on caricature. The drawing that Mrs. Moore sent me was a study of a female nude, executed mainly with a brush and India ink.

Her face was composed of a welter of dark strokes, with pools of ink for eye-sockets. Her body was rotund and maternal, the body of a contemporary Venus of Willendorf. Powerfully lit, she leans on something—perhaps a stand with a robe—supported by blunt strong toes and tree-trunk legs. By no means a conventional beauty, she seemed to be some kind of archetypal woman charged with magic.

Of course, that was how I felt about her. If Park, who died of cancer in 1960, had been alive to chat with me, he might have said "That is simply a studio study of a large model I did in the late '50s."

I was working part time at a frame store when I received the drawing, and I built the frame for the Park myself, using a heavy walnut molding that had some bulk to it. For the next ten years, it was always the first thing I hung up when I moved, and in my student years that was often.

In the summer of 1978 I followed up on Lydia Moore's invitation, and a friend and I visited her home on Santa Tomas Lane in Montecito. She and her husband, Roy Moore, were very welcoming, and I enjoyed seeing the small handful of Park paintings she still

owned, including his last major oil *The Cellist*. I remember Lydia Park Moore as being warm, just a bit scattered, and very proud of her first husband David's legacy.

I knew from having read and re-read my David Park catalog that Lydia Park had gone back to work in the early '50s, giving David what he gratefully called the "Lydia Park Fellowship" which allowed him to devote himself to painting. What he achieved as an artist had a lot to do with the devotion and support she had provided.

For much of 1978 and until my graduation in 1979 most of my paintings looked like poor imitations of David Park's works. I was heavy handed with my paint, and used broad cheap brushes from Standard Brands to apply my oil paint. In some ways my paintings were a success, as looking at Park loosened me up and took my paintings in a more emotional direction.

On the other hand, I didn't have the skills or experience in drawing to create the kinds of wonderful shorthand and sense of space that I admired in Park's late oils. I gradually realized that Park's works had a certain hard-won maturity about them. Park made me realize I would need to be very patient if I wanted to create anything that carried deep meanings.

By graduation I owned four Park drawings. I had found that there was a large folio of them downstairs at Maxwell Galleries on Sutter Street, and the prices were low. I remember that one drawing of two figures on a beach was priced at $200 but I talked my way into a $20 discount and got it for $180, paid in installments.

One of results of my interest in David Park was that I was determined to study painting with his remaining peers. In my undergraduate years I had studied with Nathan Oliveira and Frank Lobdell. Frank, in particular, remembered Park well and told me that he had helped carry buckets of paint scrapings from Park's studio during his final illness. Through a friend I was able to meet Richard Diebenkorn, but when I visited his home in Santa Monica we mainly talked about Mark Rothko. Park didn't come up.

In 1981 I entered the MA program in painting at UC Berkeley, where Park had once taught. One day after class I saw Joan Brown, who had been one of his protégés, loading something into her car. She

must have been in a hurry because when I walked over and tried to strike up a conversation, asking her "What was David Park like?" She gave me a one-word answer: "Sarcastic."

I learned more from Elmer Bischoff who told me quite a bit about Park's methods and ideas. He had been part of the group of artists who had drawn the figure together with Park at the California School of the Arts. When Bischoff came to my studio one evening for a group critique, he studied my Park drawing admiringly. "Where," he asked me, "did you get this?"

By the time I finished grad school my paintings looked much less like David Park paintings. I rarely painted the figure, and I had found my own idiosyncratic way of applying paint. I would like to think that if I could have traveled through time and showed them to Park, he might have encouraged me. Lydia Park Moore's gift to me had the effect of making me feel like David Park was indeed there in my studio, offering advice whenever I glanced towards the wall and felt the humanity of his work.

Originally published in The Huffington Post, October 10, 2010

FRANK LOBDELL: "NOTHING WORTH ANYTHING IS EASY"

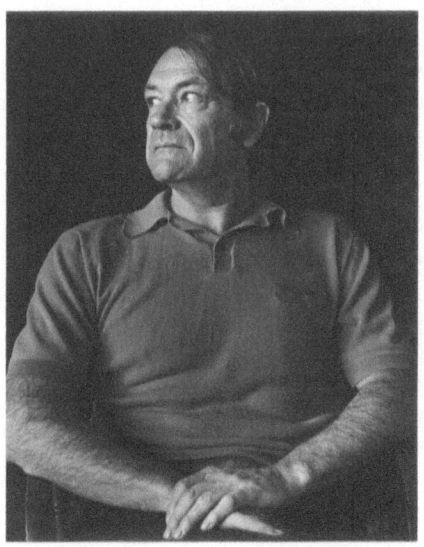

Frank Lobdell by Mimi Jacobs

After David Tomb created his mixed-media portrait of artist Frank Lobdell in 2002, he found himself totally wrung out. Working "on the spot" in Lobdell's San Francisco studio, Tomb recalls that he was "so

nervous, actually, that when I went home my neck went into massive seizure — doctors, painkillers, therapy for several months."

In his effort to create a psychologically accurate portrait of a veteran painter known for his verbal reticence and monastic studio practices, Tomb had taken on a tough subject. Just what is going on, he had to wonder, in the mind of a man whose art is a perplexing mix of the inchoate and the fantastic? Looking at Lobdell's paintings is always bracing; trying to unravel his psyche is apparently exhausting.

With his considerable effort, Tomb got Lobdell right: the strong jaw, the glowering intelligence, the unease at being scrutinized. Lobdell was "very pleased with the result" says Tomb. Of course he was: Frank Lobdell had a high respect for art that came out of struggle and pain. Robbie Conal, who had Lobdell as his graduate advisor at Stanford in the late '70s says that "Frank would mutter at me wearily, sometimes conspiratorially, every time we were together for more than half an hour; 'Nothing worth anything is easy.'"

I also studied with Lobdell—I was an undergraduate art major around the same time that Robbie Conal was a grad student, and I remember not knowing exactly what to make of Lobdell. He was a man of few words who was hard to get to know. He made a similar impression on my classmate John Littleboy:

> He [Lobdell] was broad and heavy-set and usually had a stubbled two-day growth of beard. He seemed to always have on a polo shirt and dark slacks. He might have been an athlete in his youth though that's just a guess. I took him for independent study so we saw each other infrequently. When we did, speaking seemed to be difficult for him, requiring a big physical effort to articulate his thoughts. I never doubted he wanted to be clearly understood, but that wasn't an easy business.

At the beginning of my semester with Lobdell I had it in my mind to try and copy a 17th century Poussin mythological painting, *Echo and Narcissus*. Thinking that it was my duty as a figurative painter to try and copy the work of a French master, I carefully sketched in the figures on a grid and had been at work for days before I found Lobdell standing beside my palette table. "Why" he asked, "would you want to

paint that?" That was all he had to say, and I remember thinking "That is one great question."

I had never seen any of Lobdells's paintings, and a bit later in the term I dropped by his office hour thinking he might have one of his canvasses hung in his office. Lobdell was lost in some paperwork when I got there, so I looked around and waited. On the right hand wall was an early Diebenkorn abstract oil—it was a terrific painting—but there were no Lobdells in sight. "This man has a rich history," I began to realize, "that is worth looking into."

After my Poussin copy went into the dumpster I tried an abstract picture, and it quickly turned into a chaotic mess. When Lobdell stopped by to see what I was painting I complained to him and pointed out all of the areas that I thought were unresolved. He got right to the point: "Find an area of the painting that you like," he told me. "I will be back in an hour." I followed his instructions, and when he returned I located one area of the painting where the paint had accidentally fallen into place in an interesting way. "Hang on to that," Lobdell advised.

One of Lobdell's strengths, I gradually learned, was his ability to break down a canvas, scrutinize small areas and understand how they could add up. Susan Harby, who studied under Lobdell as a graduate student, had also noticed this:

> He lived and painted a micro and macroscopic life on the canvas of forms playing out a drama or game. He looked at my work for the interaction of the small things that added up to make a good painting. He would stand inches away from the painting's surface investigating the small forms or small brushmarks and discuss how they enlivened the surface. They had to add up to something: something truthful.

In this struggle for artistic veracity Lobdell could work up a temper. He was quiet and kind in class, but in his studio he would cut loose. One Saturday I had a job cleaning up Nathan Oliveira's studio in an old VFW building in Palo Alto. Lobdell and Keith Boyle, another Stanford art professor, had studios across the hall. I remember hearing a crashing sound from across the hall—"Was that a painting hitting the

wall?" I wondered—followed by Lobdell's voice screaming out a string of curses.

Oliveira once told me that he and Frank liked to share some whiskey at the studio from time to time, and one memorable evening they drank half a bottle and realized that the liquor had unlocked their tongues. Nathan turned on a tape recorder to preserve the profound revelations about art that were unfolding, but when he ran the tape a few days later. The results were hilariously disappointing.

"When I make art," Nathan heard his drunken voice intone, "I..." followed by a long silence.

"YESSSSSS," Lobdell assented solemnly.

Robbie Conal, also remembers spending time in Frank's studio, talking art over a few drinks:

> We're sitting at what might have been a folding card table, whatever's left of a 5th of bourbon between us: I brought it. Ruminating deeply, until Frank growls, "Let's listen to some Beethoven: the late quartets." He gestures me over to the record player. I turn it on and drop the arm on spinning black vinyl.
>
> Frank booms, "Opus 131 in C# minor!" We listen for maybe 10-12 minutes in silence. He's nodding his head, eyes closed. Then, seemingly from within his reverie he says, "I know people think my work isn't pretty... that it doesn't go with the damn drapes... but when I need something for my soul—not for fucking entertainment, you know?—for my soul... I go to Beethoven! That's what my damn art is about."

At the end of the term Lobdell invited my class to visit his studio. It was an exciting opportunity. He was genuinely liked, even loved, by his students and we had passed the hat and bought him a large stainless steel frosting knife that we thought would make a good painting tool. Frank loved the knife—it was the most gigantic palette knife ever—and was visibly touched when he unwrapped it.

At his studio that day, Lobdell gave the single most riveting painting demonstration I have ever seen. Placing a canvas flat on the floor, Jackson Pollock style, he scraped some raw oil paint onto the surface and said approvingly "That's a start." In the studio, it was as if

we students had disappeared: he was letting us into the privacy of his creative process.

"Hmm... green... needs yellow."

Each time he laid down some paint, it suggested his next move, and each addition was grudgingly, tentatively applied. At first I remember thinking that Lobdell was intuitive, but as I watched the demonstration unfold it hit me: he was counterintuitive. Every scab of paint demanded a response, but the key was that the response had to be strained and unexpected. Lobdell was a tense painter, and it was the tension of the unexpected that kept him alive to his own work. His demonstration painting, as it began to add up, was simultaneously an essay in imperfection and a manifesto of sincerity.

Lobdell was "succinct" says Robbie Conal.

During a one-on-one meeting with Frank in his studio, after staring at a big new painting of his together for 20 minutes without saying a word, I asked him a question, "How do you get those fast black linear brush strokes in exactly the right place every time?"

The answer, "I paint them slow."

Lobdell, who told an interviewer in 1960 that "being anonymous is really the best condition to be able to create" was not showing very widely when I knew him, although I do remember him having a small show of monotypes at Galerie Smith Andersen in Palo Alto. Robbie Conal, who served as a Gallery Director for the College of Notre Dame in Belmont in 1979 had to work on Lobdell to convince him to show his 1961 *Summer Mural*, a 20-foot-wide phallic abstraction. "I can't quite imagine how I managed to trick him into showing the *Big Dick*," Conal recalls, "but I somehow talked Frank into unfolding and re-stretching the painting and actually showing it."

I don't remember seeing Lobdell at graduation, and in general I think he tried to avoid social situations and to some degree his students. "He left me an index card with my grade for the quarter on my glass palette" recalls John Littleboy. " I took by his demeanor that painting wasn't an easy task and whatever I did should be done with sincerity and dedication."

Twenty years later, at the opening *The Anderson Collection at San Francisco MOMA*, I saw the first Lobdell painting I had seen in more than two decades. A magnificent yellow and blue abstraction titled simply *January, 1971* it more than held its own among the top flight works by Still, Rothko, Pollock and other postwar abstractionists. I looked for Frank to see if I could congratulate him, but was told that he had missed the opening due to hip replacement surgery.

In June 2003, Lobdell's work popped up again: on the cover of *ARTnews* magazine. In a feature article titled *The Long Distance Runner*, Anneli Rufus wrote this about Lobdell:

> *Oblivious to art-world trends, Frank Lobdell has spent more than half a century doing what he wants, constantly reinventing himself and finding new territory to explore.*

The rediscovery of Frank Lobdell, my stoic painting teacher, had begun and the accolades followed. In his introductory essay for the book *Frank Lobdell: the Art of Making and Meaning* Bruce Guenther writes, "To encounter a Lobdell painting today is to engage at the highest level in a complex dance between structure and symbolism, form and meaning."

Even more extraordinary than the praise being heaped on Lobdell were the revelations about what he had seen while serving as a GI between 1942 and 1945. In a superb essay also published in *Making and Meaning* Timothy Anglin Burgard recounts Lobdell's experience, in April of 1945, of entering a barn in Gardelegen, Germany, where Nazi troops had immolated more than 1,000 concentration camp internees. I now fully understand why Lobdell, like many young American painters of the postwar generation, had chosen abstraction over figuration. When you have seen the un-seeable, painting reality becomes excruciating.

When Willem de Kooning painted his epic *Excavation*, an abstracted image of a mass grave, he had only seen news photos of what happened in Germany. Lobdell had seen Hell on Earth with his own eyes, and it chilled his soul. When he created his *Dance* series during the Viet Nam era—inspired by medieval images of the *Dance of*

Death—Lobdell's darkest memories charged the abstract imagery. "No one who is involved in one of these wars truly survives," Lobdell once told writer Terry St. John.

Lobdell, who turned 90 in August of 2011, made an appearance at Hackett-Mill Gallery, where he attended the opening of *Frank Lobdell: 1948-49*, an exhibition of a few choice works Lobdell made more than 60 years ago. Jessica Phillips, the gallery's associate director, reports that Lobdell "enjoyed seeing the work and speaking with collectors and of course former students." Part of Lobdell's legacy is certainly his influence on generations of art students: he taught at the California School of Fine Arts from 1957 until taking a job at Stanford where he taught until 1991.

"Frank Lobdell was one of my instructors at the San Francisco Art Institute in 1963," says veteran artist Ronald Davis. "He influenced my student work before I was in his class and began doing op art. I remember that he told me that, to paraphrase; 'Sometimes it is not what one puts into a painting, but rather what one leaves out that makes it a compelling picture.'"

Truthfully, part of Lobdell's power as a man—and as an artist—is that he told us so little for so long. It is energizing, and exhausting, to read between the brushstrokes of a man who meant every word and every brushstroke. There was effort, sincerity and meaning in every single one of them.

Originally published in The Huffington Post, February 10, 2011

MY VISIT WITH RICHARD DIEBENKORN

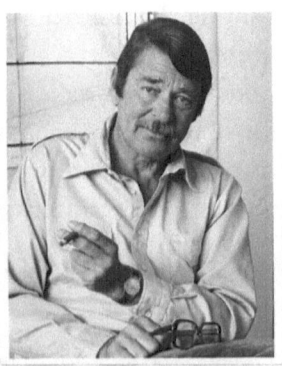

Richard Diebenkorn by Mimi Jacobs, 1977

I came home from college for Thanksgiving break in 1977 and told my parents that I wanted to major in art. They found my decision quite upsetting. Although I had always been creative growing up, I was a conventional young man, who everyone expected to take a conventional path in life. So when I entered Stanford University in 1975 it seemed likely to my family that I was well on my way to becoming an attorney or businessman and gaining lifetime membership in America's upper-middle-class. As far back as I can remember, my parents,

friends, relatives, teachers and other concerned adults had been patting me on the head and saying:

"John, you can be anything you want."

However, they had all failed to warn me about the one profession that was outside the range of possibility. "You can be anything you want," they should have cautioned, "except an artist." This omission created, in my second year of college, what I am going to call the "Diebenkorn problem." I had decided that I wanted to become a painter. In other words, I wanted to enter a profession that my family associated with poverty, alcoholism, scraggly beards, chain-smoking, and permanent financial dependence.

The problem first appeared in my freshman year, when I discovered that I had left my tennis racket at home when I packed for college. Since I couldn't enroll in tennis—which I had chosen as a nice, easy class—I decided to take a painting class instead. I had been drawing cartoon characters since the age of six, and although I had taken no art in high school, I figured I could fake my way through a painting class. Once the class got going I saw how far behind the others students I was, so I began to work hard to see if I could catch up.

My fascination with art—like any addiction—got serious fast. By the end of my second semester I was painting on the walls of my dorm room—one was a bad copy of a Paul Klee—and reading art magazines in the college library until midnight. I was also taking art history classes and began ostentatiously peppering my speech with French and German and even Italian words: "Fauvist," "kitsch," "Quattrocento," and so on.

Even more dangerous was the appearance of a mentor in my life: Professor Nathan Oliveira, a painter. As soon as I met him, Nate had a magnetic pull on me. Here was a man who loved what he did, who had a great way with people and was a tenured professor: a secure member of America's upper middle class. Maybe there was a way I could follow my family's script, just with a twist. I could become and painter and professor like Nathan. Or, better yet, I could become the next Richard Diebenkorn.

Like the other students hard at work in the Stanford painting lab—

where I was now spending nearly all my time—I had come to admire the artist's hazy blue *Ocean Park* paintings, which were gaining a national reputation for their serene geometry and painterly evocations of atmosphere. After landing a part-time job as in intern to the Anderson Collection, where several Diebenkorn paintings were on display, I got to know Diebenkorn's work up close. I used to stand in front of *Ocean Park #60*—which was on display in the conference room of Saga Foods—and just stare. The canvas—just a bit taller than me—was mesmerizing, carefully structured and somehow otherworldly. It also had dozens of brush hairs trapped in its surface, which struck me as reminders of the physical effort that had gone into painting it.

Diebenkorn was a friend of Nathan's and by prying I was able to learn a few things about him. Richard Diebenkorn—"Dick" to his friends—drove a Porsche. He had been a Professor at UCLA, but had recently resigned as he didn't care for the committee work and no longer had to rely on the income from teaching. Diebenkorn was annually producing something like a dozen large *Ocean Park* paintings that were sold in short order to a waiting list of collectors who paid amounts in the low six figures. Along with Sam Francis, Diebenkorn was one of most respected and financially successful artists in California and the United States.

He was also a tall, square WASPY sort of guy: I could relate. When I say Diebenkorn was "square," he was the only artist I knew of that used rulers to draw lines on his canvasses. That is square. As I fantasized that I might someday have a career like his, I didn't think rational, mature thoughts like "Maybe the man is just immensely talented, and that's why he is doing so well." I set my sights and declared myself an art major.

When I mentioned Diebenkorn around my family, it turned out that they knew something about him. Apparently my Aunt Alice had attended Stanford after the war where Phyllis Gilman, who later became Phyllis Diebenkorn, had been a friend and a member of the same graduating class. My aunt was very familiar with the story of how poor Phyllis had married an artist and how other women had gossiped that she would now be facing a life of poverty. We all know how that turned out...

Then, one day at my grandmother's house, I ran into Esther Slinger. Esther, a longtime friend of my grandmother's turned out to be Phyllis Diebenkorn's aunt. When I mentioned that I was a painting student, Esther told me her most sensational Diebenkorn story:

I once visited Dick and Phyllis when they were living in Berkeley, and I saw him painting. He actually THREW the paint at the canvas.

Maybe Esther was trying to help out my family by scaring me back towards respectability, but her comment backfired. It helped me shift my view of "square as toast" Dick Diebenkorn as being a bit closer to Jackson Pollock. My personal fantasies about my future as an artist become more detailed. Someday, I would drive a Porsche—as Diebenkorn did—and throw paint while wearing Brooks Brothers shirts. I would somehow manage to be both conventional and intellectually flexible as I observed Diebenkorn to be. In other words, I had a very shallow and idealized fantasy about what it meant to be an artist.

In October of 1977 the Diebenkorn Retrospective opened at the Oakland Museum, and I studied the show up and down. In fact, I wrote about art for the very first time in my life and got my review published in the *Stanford Daily*. It was a truly awful piece of writing that sounds very forced when I read it now:

Formula-painting seems the real subject of the "Ocean Park" series. Every one of these large paintings, to a large or small degree, recalls a beauty which Diebenkorn's compulsive personal sensibility has distilled from the landscape.

The review got Nathan Oliveira's attention, and he apparently even mailed a copy to Richard Diebenkorn, a thought that now makes me a bit nauseous. Then, one day during class Nathan walked me away from the other students into a dark corner of the painting studio. What, I wondered, had I done wrong? He handed me a slip of paper torn from a yellow lined pad and told me:

Give Dick a call. He is expecting to hear from you.

A few weeks later I pulled up at the curb of a house that sat on a winding road leading out of Santa Monica Canyon. Yes, there was a Porsche in the driveway, but that is a given for Pacific Palisades. The house was Spanish Colonial in style and had a tile walkway leading to a wrought-iron grille. A dog barked when I rang the bell.

The man who answered the door was quite relaxed and somehow

already familiar. Writer Dan Hofstadter beautifully describes the Diebenkorn I remember in his book *Temperments:*

He has something of the appearance of a leading man in an old-fashioned drawing-room comedy: the sculptural planarity, the dark emphatic eyebrows and mustache—deep clefts running like parentheses from cheeks to chin—clefts that behave like dimples and help to give him his genial, kindly appearance.

As I walked in—a real stunned fish as visitors go—I couldn't really pay any attention to Mr. Diebenkorn, since the walls had me staring. On the living room wall was a large Diebenkorn canvas that showed the influence of Matisse: Diebenkorn's *Large Still Life* from 1966, now in the collection of MOMA. There were also some small drawings from India—including one of an elephant—and a nude in charcoal by Los Angeles artist William Brice.

The house, which was L-shaped, wrapped around a patio filled with potted trees and director's chairs, and had a stunning view across Santa Monica Canyon. I remember thinking that I must be in the South of France. Phyllis Diebenkorn came in and said "hello," but then stayed quietly in the background. When she did appear, I couldn't help but notice the couple's calm connection with each other.

When we sat down to begin our visit, Diebenkorn took a seat in his comfortable armchair, and I brought out a portfolio of my own ink drawings. They had been done with a bamboo pen, influenced by similar works in a book of Diebenkorn drawings that I had purchased at the Stanford Bookstore. I had brought the book with me for Diebenkorn to sign. I was still in a kind of daze when it hit me that I was showing Richard Diebenkorn my work.

How did he respond? I think it's fair to say that he was pleasantly underwhelmed. He made a few gentle comments about my use of line and the whole portfolio was set aside in ten minutes.

The visual memory of Diebenkorn's home and surroundings have stayed with me more than what we talked about. Tea served with lemon—in china teacups that made me think "Matisse"—a dining room that had curved windows and some Diebenkorn figure drawings hanging on the wall. Afternoon light casting shadows on the big Matisse-inspired still-life in the living room.

Toward the end of our conversation Diebenkorn talked at some

length about his respect for the work of James Doolin who had been one of his graduate students at UCLA. Doolin, he explained, had spent several years working on an aerial view of Santa Monica Mall. They had flown over the mall together in a private plane so Doolin could take photos. It was a very ambitious project that Diebenkorn, who had served as Doolin's advisor, thought highly of. Years later when I met Doolin, he was very touched when I relayed Diebenkorn's admiring comments.

Our visit came to an end just after Diebenkorn opened a catalog of paintings by Mark Rothko. He was leafing through them and commenting, somehow testing to see if I might have anything interesting to say. He opened a page in the front of the book, showed me an early Rothko and asked: "Whose work does that remind you of?"

I had no idea. He had hoped—I guess—that I had a deep knowledge of painters and painting. Soon after that, our visit was over. It's not as if the man kicked me out of his house for not knowing that Mark Rothko had an early period where he took ideas from John Marin—I figured that out in the Stanford library the following week—but I did sense that he was a bit disappointed.

Then, as he walked me to the front door, he said, "Please give me a call sometime if you want to visit the studio." I was too shy to ever call him: what a missed opportunity. I did go back to the house a few years later when I helped a friend publish a Diebenkorn poster. Diebenkorn politely claimed to remember me as he fiddled with a box of pens while looking for the right one to sign a few posters. The house looked the same. The Diebenkorns had a settled life.

By the time I had my graduate degree in Painting, it was 1982, the art world was coming to a boil, and new artists were making headlines. Clemente, Schnabel, Basquiat—young, splashy, challenging talents—made the work of Diebenkorn and his generation look sedate in comparison. I continued to admire Diebenkorn's work, but meeting Diebenkorn had somehow made him more human and less of a figure to be fantasized about.

When I was working for art dealer Larry Gagosian in 1983, the gallery was only half an hour from the Diebenkorn's house, but it seemed worlds away. I had landed right in the epicenter of a new kind

of red-hot art world where reputations came and went overnight and paintings were—more than I had ever imagined—expensive investments meant to be brokered and even "flipped."

I hadn't heard Diebenkorn or his art mentioned at all until one day Larry and his client, the film producer Keith Barish, spilled out of Larry's office laughing hysterically. They were like a couple of ten year olds who had just heard a dirty joke, seized by an uncontrollable laughing jag. Seeing me at the front desk—an easy target—Larry let me in on the joke.

"Keith and I have a question for you. What kinds of collectors buy Diebenkorns?"

I shrugged.

Larry offered the punchline: "Rich Jews."

After that, the pair laughed all the way out to Barish's Bentley. I found myself wondering what Barish—a Jew himself and also the producer of the Holocaust-themed movie *Sophie's Choice*—could possibly see as funny. Was Barish considering buying a Diebenkorn while feeling embarrassed by his own Jewishness? Why was he more worried about social tokenism than the qualities of the art itself? The implications of the joke—all of them cynical—bothered me then and continue to bother me now.

What I began to realize after hearing that joke—which followed six months of working for Larry Gagosian—was that there could be head-spinning contrasts between an artist like Diebenkorn and those who sold and coveted his work. I was fortunate to realize, through my direct encounter with him, that Richard Diebenkorn was astute, classy and cultivated. Those personal qualities made an indelible impression and motivated me to better understand Diebenkorn's art.

Originally written for the author's website in 1997.

A CRITICAL PIECE OF ADVICE ROBERT DE NIRO SENIOR GAVE ME ABOUT ART

Robert De Niro Sr. by Timothy Greenfield-Sanders

In the late 1970s, just after I had earned my bachelor's degree in art, an art dealer offered to introduce me to the painter and poet Robert De Niro Sr. Since I admired De Niro's work, I called and asked if I could drop by sometime and show him a few of my paintings. He said "Yes."

De Niro, who lived in New York City, was briefly staying in the Bernal Heights neighborhood of San Francisco (painting and helping a friend extricate her daughter from the Moonies) in a small home that had a distinctly Bohemian air. I remember strands of glass beads

hanging in the doorways and a caged green parrot named Demetrius. As I showed De Niro a group of my recent canvases—brushy landscapes of coastal scenes—I nervously rattled off a list of influences. This composition showed that I had been looking at Diebenkorn; the color relationships of this study were inspired by Van Gogh's palette; I was thinking about Corot's ability to suggest atmosphere when I painted this one and so on.

After patiently enduring my pompous monologue, De Niro—who had been quietly inspecting my work—made it clear that he was unimpressed by my attempt to justify my work by connecting it to that of famous artists. He told me: "Don't worry about whether your work looks like anyone else's. As you paint, you simply need to ask yourself 'Is it any good?'"

De Niro's sage advice has stayed with me, although I remember finding it intensely challenging when first offered. Just how, I wondered, could I find out what made art "good"? How would I ever gain admission to the Art World, which I had come to realize was a very complicated and foreboding social construct. Was I really supposed to search my own soul—and develop my own sense of judgment—instead of holding *Artforum* in my left hand while painting with my right?

The implications seemed overwhelming. Like most art students I had been spending as much time as I could visiting museums and galleries and poring over art books and magazines. But I gathered De Niro wasn't necessarily suggesting I do more of that—that would just have given me a longer list of influences. He was instead telling me I had to develop an internal and highly personal way of discerning and measuring quality. He was, of course, right.

What De Niro's comment challenged me to do—to turn inward—is something that every artist needs to do, unless they are content with being an epigone: a lesser follower of a recognized artist. Turning inward was hard to do when I was young, and it seems even harder now, with the vastly entertaining deluge of images that come our way through social media, each picture a deftly contrived piece of eye candy. It's hard to think deeply about what makes a work of art "good"

when you are holding an iPhone, scrolling though Instagram and "liking" the art of anyone you want to flatter.

And for artists who are yearning for the sense that their art at least has social value—or even a sliver of profundity—has it ever been easier to earn instant mass validation? Even if you live like a hermit in a one-room cabin in Montana, your latest daub can still earn 1,000 likes in an hour. If it doesn't, you can hire a click farm in Asia and present the illusion of being massively "liked." I worry that someday art historians may look back at this era as the one in which easy likes replaced hard-earned plaudits.

Standing in front of your own work and asking yourself "Is it any good?" is not a recommended activity for the immature or insecure. It needs to be done in the privacy of the studio with all devices turned off and all outside biases and preconceptions (including your own) absent. Philip Guston was referring to this situation when he once spoke about "studio ghosts":

> *When you're in the studio painting, there are a lot of people in there with you—your teachers, friends, painters from history, critics ... and one by one if you're really painting, they walk out. And if you're really painting YOU walk out.*

The kind of quiet and emptying out needed in the studio is perhaps similar to what one might experience during a silent retreat. I recently met a woman who had taken a ten-day Buddhist retreat, and I asked her, "How did it go?" She replied: "For the first few days, I was climbing the walls." For an artist, letting go of all of the external influences, forgetting about what sells and what doesn't and not caring what your friends and family think will also likely induce—at first—that same sense of anxiety.

But when you start asking yourself "Is it any good" on a regular basis and do so with a sense of sincerity and focus, your work is bound to improve. Just thinking hard about what is "good" in art will give you an endless stream of questions that will occupy your mind whenever it needs something to chew on. This state of questioning will produce greater humility and authenticity. That, in turn, will be accompanied by greater maturity and freedom.

The painter David Park—whose work changed profoundly in mid-career after he abandoned the then dominant style of Abstract Expressionism—understood this very, very well. He said: "As you grow older, it dawns on you that you are yourself—that your job is not to force yourself into a style, but to do what you want."

Originally published on Hyperallergic.com, June 18, 2018

MAZURKI: THE MULTIPLE MEANINGS OF A PHILIP GUSTON DRAWING

Mazurki *by Philip Guston,* ©*The Estate of Philip Guston*

On November 13, 1980 I purchased a drawing called *"Mazurki"* by Philip Guston for $4,300.00 from Gallery Paule Anglim in San Francisco. I still have the receipt, but sadly, not the drawing. When I bought it, I was 23 years old, a recent college graduate working as an art salesman in a shopping mall. I didn't have the $4,579.50 —the total with tax—needed to pay for the Guston, but I did have a $500.00 deposit, and the very trusting Ms. Anglim let me take the work home, assured that I would make the payments of $500.00 per month.

What on earth was I doing spending forty-five hundred dollars on a work of art? The drawing cost more than double what my car, a used Volkswagen sedan, had cost me the year before. Come to think of it,

since gas sold for 85 cents a gallon at the time, the Guston was equal to about 5,000 gallons of gas. Why on earth was I willing to spend so much money on a single sheet of paper? There were really several motivations for my grand purchase.

A few years earlier, during my junior and senior years as an art student at Stanford University, I had worked as an intern to the collection of Harry and Mary Anderson, better known as "Hunk and Moo." Through being around the Anderson's vast collection and frequent visits to their home, I became familiar with the feeling of being surrounded by challenging works of modern art. Working for the Andersons had introduced me—in a big way—to the pleasures of living with works of art.

One afternoon in 1979 I was in the Anderson's foyer with a group that included some Stanford art students and faculty when I found myself standing in front of *The Coat II,* their freshly acquired Philip Guston painting.

Dr. Albert Elsen, a Professor of Art History and an intimidating man, stood beside me and stated that the Andersons had wasted their money. Dr. Elsen, who had served as an advisor to the collections in their early days, was not alone in his feelings. At this point in time Guston's representational paintings were widely disliked. The Andersons were among the few collectors who believed in what the aging artist was doing. What most collectors wanted were Guston's graceful abstract paintings from the 1950s, not the shaggy late works that had caused New York critic Hilton Kramer to title his scathing review of Guston's new works *A Mandarin Pretending to be a Stumblebum.*

Without thinking too hard about it I replied to Dr. Elsen: "I love that painting." He responded by asking me, "Why?" Dr. Elsen's blunt question totally stumped me. I babbled something and felt the flush of embarrassment at the total inadequacy of my answer. One reason I may have later been compelled to buy a Guston was so that I could develop a deeper understanding of the man's work and answer Dr. Elsen's question for myself.

The following year I was totally bowled over by a retrospective exhibition of Guston's work at the San Francisco Museum of Modern Art. His shaggy, maudlin, late paintings, many of them still smelling of

linseed oil, made a powerful impression on me and deepened my interest. They had something to say, it seemed, that represented hard won wisdom and courage.

The Guston show was strong stuff. I'd gone to the exhibition with a friend who was in medical school, and she literally couldn't handle one painting that featured a pile of legs. I could handle the Gustons—I saw poetry in the violence—but I was grossed out a few months later when the same friend took me on a tour of her lab at UCLA where she was slicing brains with a Hobart meat slicer.

Guston died in June of 1980, a month after the opening of the San Francisco show, and that also brought a sense of urgency to my feelings about his work. By the time I heard about a show of his drawings being held at the Anglim Gallery in November of the same year, I was convinced that Guston's art was somehow crucial to me. "I will buy a Guston," I thought grandiosely, "the way that Matisse bought the small Cezanne that became a cornerstone of his artistic life."

When I arrived at the gallery and remember seeing maybe eight or ten spare black and white Guston images. More than half were already sold, and *Mazurki,* which was still available, caught my attention. It featured two horizontal rows of blunt, hieroglyphic images that I found interesting and a bit peculiar. It wasn't long at all before it was hanging on the wall of my rented room, radiating mystery. Owning *Mazurki* made me feel I somehow had a foot in the door of the art world, a very imposing social and economic hierarchy that I wanted to be part of.

The Guston drawing certainly gave me something to contemplate, and to puzzle over, but I was never really able to identify all the objects that it contained, or to give the work any kind of fixed meaning. I knew there was a Polish dance called a Mazurka so I assumed that the title meant "a lot of mazurkas" and left it at that. Knowing that Guston had been born in Russia somehow seemed connected to that.

After staring at it for a few months I decided the work somehow involved associations the artist had about his father who had been a railway machinist. I saw a gear and a cam, a beer mug and beer bottle, and a book filled with vertical dashes. I also thought over the fact that the drawing had been made as an illustration for a book of poetry,

ENIGMA VARIATIONS, by Guston's friend, the poet and art historian Bill Berkson. Although I never tried to obtain a copy of the original poem, I kept it in mind that my drawing was enigmatic along the lines of the poetry that it had accompanied.

By 1981 I had enrolled in UC Berkeley as a graduate student in painting, and the Guston was part of my small collection that included a painting by Robert de Niro Sr. and several drawings by David Park that I had purchased for $200 each. Friends and visitors to my studio rarely commented on it and few would have recognized it as anything of value. One exception was the ceramicist Robert Arneson who visited during an open studio day, and he was mightily impressed.

By 1984 I had finished graduate school and had student loans and credit cards to pay. Foolishly, and a bit desperately, I looked for a buyer for the Guston, and eventually traded it for a work by Patrick Hogan that I then promptly sold for $2,700. A friend of mine says you should never sell California real estate. I wish someone had told me as a young man that you should never sell your art collection.

It has been decades since I owned *Mazurki* but while going through an old photo album, I recently came across a snapshot of it hanging in the corner over my bed. As I thought it over, I began to realize that even though I no longer owned the image, it would be a good project to do some research and answer a question that still nagged me: "What was *Mazurki* about?"

It didn't take much effort to find a copy of Bill Berkson's *ENIGMA VARIATIONS* for sale on the internet, and when it arrived I found that the poem *Mazurki* was the second poem in the book, opposite the image of the drawing that I once owned. Reading the poem—which Guston had in mind when he created the image—was something I should have done years ago.

Mazurki

Going
Thirsty
Sidelong
Plus

Duffle
Longer
Modish
Plugged
Ticklish
Simple
Hopeful
Double
Grounded
Slept-in
Sure
Uncertain
Glazed
Familiar
Hung
Deliberate
English
Tonal
Garbed
Terrific
Even
Undiminished
Plural
Anecdotal
Laid
Friendly
Shot
Decided
Torn
Rabid
Crazy
Little
Tops

poem by Bill Berkson
from ENIGMA VARIATIONS

Big Sky, 1975

Reading the poem certainly didn't make me suddenly think "OK then, I now understand everything I need to about the drawing." Just how a poem with a single plural noun, the title, a singular noun, "duffle," and 36 adjectives was connected to the cryptic forms of the drawing was going to be hard to fathom. I was going to need some help.

Fortunately, I was able to contact Bill Berkson via e-mail, and he was more than willing to answer some questions that I really should have asked years ago.

First I asked him about the title, and here is what he had to say:

Mazurki is two things in my mind: 1) plural of mazurka (Polish dance); and 2) Mike Mazurki, an ex-boxer-type character actor in 1940s movies. The mazurka part is how the poem 'turns' on its one-word lines, all of them adjectives. I'm fond of the poem; I've never written another like it.

Mr. Berkson also took the time to tell me about the objects to be found in the Guston drawing:

John, some are generic Guston objects, but some objects in the generic-Guston modes of meta-object—objects that could be one thing and another. 'You're painting a shoe, you start painting the sole and it turns into a loaf of bread; you're painting the bread and it becomes the moon ...' (inexact quote of what PG said to me).

When Berkson told me how he identified the objects I found there were some surprises for me, particularly in the fact that he suggested that one object could *"morph"* into something else. So, a poem with thirty-six adjectives had inspired Guston to pen a group of things capable of being more than one thing, some of them cryptic and personal. Both Mazurkis—the drawing and the poem—seem designed to multiply ambiguities, just as the title *ENIGMA VARIATIONS* would suggest. Some of the adjectives could seemingly link to some of the images, for example "Thirsty" goes nicely with a bottle, but where

could I find am image that works for "Laid" or "Shot"? Add to that, the adjectives found in the poem could describe qualities or states of objects or of people, or of both.

Of all the adjectives in the poem "Uncertain" best describes how I now felt about both the poem and the drawing. Pursuing any kind of fixed meaning for either would not seem to be a good approach. The poem seems to say "these words can spin you in any direction you like." In response, Guston's drawing seems to say: "I have a stable of hard-won personal symbols, and the poem has elicited some of them. Make of them what you will." As it turns out, that isn't too far from what Guston actually did.

A comment in Bill Berkson's e-mail to me led me to contact the Special Collections Department of the Thomas J. Dodd Research Center, at the University of Connecticut. There, among papers donated by Mr. Berkson, archivist Melissa Watterworth located a note from Guston himself, which he had attached to the drawing for Mazurki when he created it. What a find: I now had, in Guston's scrawled handwriting, his own thoughts about Berkson's poem.

I love this poem - the words - I mean the "list" - keeps on working - active - never stops, I mean to say - perhaps that's what I meant by my little object pieces THINGS - as the eyes roam around anywhere in life.
 - Philip Guston

Guston's note had now taken me as close as I would ever get to understanding the drawing. Apparently, the very complex, enigmatic drawing came from the simple acts of looking, seeing and remembering simple objects that were familiar to the artist.

There must be a lesson somewhere in this story. Clearly, when I was younger, my instincts told me to value and look at the work of a mature artist, but I certainly didn't look all that hard at the time. I valued Guston, but not enough that I ever took the time to really understand what I had when I owned it. If I had known just how complicated, subtle and changeable the meanings behind the drawing were I would have hung on to it.

If Dr. Elsen were still alive maybe I would send him an e-mail and

finally get back to him about why I like *The Coat*. I did see him at a college reunion just before he died, and I doubt he remembered me. If he were around now I might tell him that one of the reasons I now write about art is that his challenge to me caused me to want to better explain in words how I feel about works of art.

I was amazed at the pull I felt recently when I came across a snapshot of *Mazurki* in an old photo album. Maturity must make some kind of difference, and now I can at least say that I know something about the collaboration between Bill Berkson and Philip Guston, and what kind of ideas they were working with. They valued looking, poetry, ambiguity, suggestion, collaboration and introspection. *Mazurki* challenged me to absorb and adopt those same ideas.

Originally published in The Huffington Post, January 11, 2011

JOAN BROWN: TOWARDS UNEXPECTED JOY

Joan Brown by Mimi Jacobs, 1980

In the fall of 1981 I was an incoming graduate student in Painting at UC Berkeley, anxious to meet my new professors, including the respected Bay Area Figurative artists Elmer Bischoff and Joan Brown. Because I was so intent on getting Brown's opinion of my work, I scheduled an individual critique with Joan and installed a recent 7' x 9' canvas in UCB's downstairs gallery especially for her viewing.

Joan arrived promptly, a striking woman with piercing eyes

accented by heavy mascara and bright hennaed hair. She immediately made stinging observations about my work, which was titled *Dead Duck*. She told me that my painting—a cartoonish canvas depicting a duck being shot out of the sky—was incoherent, impossible to respect, and lacking in focus.

It was the harshest critique I had ever received. Stunned, I asked Joan if there wasn't anything she liked about the work. I will never forget her response, which she made in a raised voice as she stormed out of the gallery:

"You need your ass kicked."

Although I later took Brown's class and saw her softer side, that first impression has lingered with me for 30 years. Brown—both in her words and in her art—was uncompromisingly assertive. Her toughness didn't endear her to everyone, but over the long haul it was the quality that distanced her from a difficult childhood and moved her towards the visionary optimism that characterized her final works.

Jodi Throckmorton, an Associate Curator at the San Jose Museum of Art, frames Brown as a strong, original individual who avoided ideology. Although often seen as a feminist, Brown's life and art fall into a kind of "grey area of feminism" according to Throckmorton. "Her apolitical approach to the subjects of domesticity, gender, aging, relationships, and motherhood may be the cause of her exclusion," Throckmorton writes. "Nonetheless, time has shown that her choices as a woman and as an artist were anything but neutral."

The title of the San Jose exhibition is taken from the title poem of Diane di Prima's book *This Kind of Bird Flies Backwards* and was chosen because Brown and di Prima—a rare female beat poet who used street language—seem like kindred spirits. Both were women who uncompromisingly made their way into male dominated fields while struggling to maintain their identities as women. Adele Landis Bischoff, whose husband Elmer was an important mentor to Brown in the late '50s, recalls that Brown was indeed a tough young bird. "Early on when I met her," Landis recalls, "she was like a young (if a rooster can be female) she was like a rooster."

Brown's biographer, Karen Tsujimoto, puts it this way: "In her art she had no one whom she had to answer to or to be responsible for,

and she relished and protected this freedom fiercely." Joan was an artist and an individual first. "I can't do without making pictures of my own," she once commented. "And I don't know why this is so. But it's true…"

Brown's toughness was, in fact, the result of a childhood that was emotionally claustrophobic. The only child of an alcoholic father and a mother who often threatened to jump off the Golden Gate bridge and who eventually did take her own life in 1969, Joan later recalled her early years as being "…dark, I mean dark in the psychological way." She was anxious to grow up quickly; "All I wanted to do was grow up and get the hell out of there." Joan Beattie graduated from high school a self-proclaimed "con artist" who knew when she could get away with things, and when to fade into the woodwork.

Seventeen-year old Joan's life pivoted when she noticed an advertisement for the California School of Fine Arts, which she decided to attend instead of the Catholic college her parents had in mind. Entering in 1955, she fell in love with the beatnik atmosphere of the school: bongo drums playing in the halls, guys with long hair, beards and sandals. Bright and charismatic, she immediately attracted male attention. "I have this extraordinary student," Elmer Bischoff told his colleague Wally Hedrick. "She's either a genius or very simple."

In her first year at CSFA Joan married her first husband, painter Bill Brown, met important artistic mentors including Bischoff and Frank Lobdell, and also connected with another student, Manuel Neri, who would be her second husband and the father of her son Noel.

Brown's student paintings were "clumsy," and she became something of a school legend because she was always covered with paint from head to toe. Moving back and forth between abstraction and figuration, she gradually developed a representational style that had a kinship with the "Bay Area Figurative Style" championed by several of her male instructors. Brown didn't feel held back by being a woman: in a sense she was one of the guys and later remembered being "supported like hell" by the men who surrounded her.

In 1959 her paintings caught the attention of visiting lecturer David Park who said, "I just love these paintings." Her mentor Elmer Bischoff felt differently—"I can't stand them" was his comment—but her thickly painted works had an affinity with Park's late canvases. It

was Park's dealer, visiting from New York, who dropped by Brown's studio by accident in 1959, paid $300 for two of her paintings and launched her career. Brown was so convinced the check was fake she took it to her father, a bank employee, to see if it was real.

By 1962 Brown, now married to Manuel Neri and about to become a mother, had shown in New York and at the Whitney Museum. A 1961 trip to Europe with Neri had opened her eyes to Goya, Velasquez, Rembrandt and other masters, and she had a great studio relationship with her new husband, a sculptor. Unfortunately, she would later recall, the studio was the only place they ever got along.

A 1962 painting, *Girls in the Surf with Moon Casting a Shadow*, shows the "cacophony of pure color and energy" that Brown could generate. The encrusted, ragged slabs of pigment, achieved with inexpensive Bay City paints poured from one gallon cans, have some of the craggy abstract energy of Clyfford Still, but the poetry and goofy tenderness of the image was Brown's alone. She had borrowed her subject matter —nudes by the water—from Park and Bischoff, and reconstituted them with a helping of gentle, slapdash parody. Bischoff's nudes of the early '60s have a Wagnerian seriousness about them, while Brown's figures are ice cream sundaes in paint, with a cherry on top.

Driven by her need to tell stories, Brown's style moved over time towards illustration, and thinly brushed lines of enamel began to supplant and replace the heavy, troweled applications of oil paint. Because she started out by emulating the heavily-painted style of earlier Bay Area artists, Brown never mastered traditional rendering. She was to some degree always a naive painter. Recognizing this, she took to heart the example of Henri Rousseau and let stylization, narration and a dose of Egyptian stiffness carry her work. In *The Journey #1* she appears leading a lover forward in a frieze-like composition; it's clear who is in charge. Like many of her best paintings, the image is crisp, smart and engaging.

Brown was a prolific maker of self-portraits that broadcast her considerable emotional range and also her social observations. Her densely patterned 1977 *Self-Portrait,* which has been said to "call into question the stereotypical image of the female artist," demonstrates that Brown's way of exploring the role of women was to start with her

personal experience. It also seems like a transitional painting in which an artist seeking clarity and order rises above the mess that covers her floor. Within a few short years Brown's art and imagery would enter a distinctive new phase.

A 1980 trip to India with her 4th husband, SFPD officer Michael Hebel, brought her into contact with Sai Sathya Baba, a yogic guru who insisted on the divine nature of all men and women. When Sai Baba briefly made direct eye contact with Brown during a blessing ceremony at his ashram, she later told friends that she had developed a red third eye on her forehead. From that point forward Joan became one of his devotees and incorporated many of his teachings into her art.

Brown's imagery took on a new turn, and her canvases began to fill with animal images; one was the tiger, her Chinese astrological symbol. Esoteric signs and symbols replaced the domestic situations of the previous decade. The paintings and public artworks that Brown created in the final phase of her life were stocked with a bestiary of birds, cats, dogs and fish as well as hybrid creatures that illustrated Brown's personal belief that the Age of Aquarius was indeed dawning. One assignment she often gave her undergraduate painting students was to paint themselves in the form of animals.

"One of my main interests is archeology and anthropology," she told Zan Dubin in 1986, "and in the last 10 years I've traveled to archeological sites in Egypt, India, South and Central America and the Orient. In the art I saw, the thread running through all the ancient cultures is the symbolism of a golden age—whether represented by the yin and yang or by men and women shown as the sun and moon." Brown's New Age convictions, and her continuing insistence on doing things her way, gave her images a cryptic quality. "Brown," states journalist Abby Wasserman, "after all is said and done, has written in a code known only to her."

Critics often gave Brown a tough time. In a 1986 review of Brown's exhibition *From the Heart*, Colin Gardner of the *LA Times* called Brown out for her "self-righteous body of work," and didn't stop there. "This art is so absorbed in its own blinkered ego that it makes the need for critical response totally irrelevant," he wrote. Of course, Gardner

wrote that just before the similarly self-righteous qualities of Frida Kahlo's paintings began to draw critical attention and public adoration.

After her heart-opening introduction to Sai Baba in 1980, Brown tried to create works that expressed her new ideals of service and compassion. In the 80's Brown's public works began to appear in "democratic" spaces including parks, plazas and shopping malls. Her 36-foot-tall *Horton Plaza Obelisk*, dedicated in 1985, is divided into three sections—the earth, sea and sky—and features images of a jaguar, fish, the sun and the moon. In a lecture given to a San Diego Sai Baba group coinciding with the monument's dedication, Brown stated that her art was an expression of "...the super-conscious, which is a very spiritual way of being."

In the fall of 1990 Joan was in India completing the project of a lifetime, an obelisk meant to celebrate Sai Baba's sixty-fifth birthday. In a freak accident, a concrete turret of the new museum where the installation was taking place collapsed, instantly killing Brown and two assistants who had traveled to India with her. By the time of her death at the age of 52, Joan's dark childhood had faded into a distant memory. Six months before, she had written to Sai Baba, who she now considered to be both her spiritual mother and father in one being: "Words cannot express the great joy and gratitude that I feel within my heart."

It hadn't been an easy journey, but painting the story of her own life as a visual diary had turned Joan Brown inside out, opening her up to unexpected joy.

Originally published in The Huffington Post, October 18, 2011

WORKING FOR LARRY GAGOSIAN (1982-83)

Larry Gagosian and Jean-Michel Basquiat, 1982

The last time I saw Larry Gagosian was at a *Museum of Contemporary Art Los Angeles* fund-raiser in 1985. The event, which featured an art auction, took place on the cruise ship that had been featured in the TV Show *The Love Boat* and had been organized by Douglas Cramer, an art collector and the show's producer. After the auction ended I was standing on the deck watching the crowd when Larry suddenly appeared.

I hadn't seen Larry for more than a year, but I recognized him instantly. His grey-flecked hair made him at first appear older than he was—I think in his mid-thirties—but he had the wary eyes of a rebel-

lious teenager searching for ways to get into trouble. Larry had a way of looking at you that made you feel looked through and looked past at the same time. When I try to picture Larry, I see his intensity more than I see his features.

He recognized me and offered a quick boast: "Hey, John, I bought the Eric Fischl." There was no "how are you?" or other small talk, and seconds later Larry vanished, another shark in the sea of Armani-clad art collectors and minor television stars. When I stopped by the museum accounting office a week later to pay for something I had bought, the museum's bookkeeper asked me: "Don't you know Larry Gagosian? He hasn't paid for his piece." Apparently he never did pay for it, which was classic Larry. He must have wanted to flip the Fischl for a quick profit, and when that didn't work out he simply forgot about it and moved on to other gambits.

I had worked for Larry for six intense months beginning in December of 1982, and I was well-acquainted with his opportunistic approach to cash flow. When I recently read somewhere that Larry is now considered the most powerful art dealer in the world, I had to shake my head. Was this the same guy who wouldn't pay the bill from Wally's Liquor Store until Wally himself appeared at an opening waving the invoice? How could someone who was so cavalier about paying his bills become so successful?

Of course, the Larry I remembered had very much wanted to be rich. Once when I had picked Larry up at LAX to drive him home, he told me that he had decided—after thinking about it quite a bit—that being rich in America meant having a net worth of twenty million dollars. Larry's remark made an impression on me since I was making $1,000 a month as a gallery gopher and just couldn't envision money on that kind of scale. I was working for Larry because I was very interested in what he sold, but I was totally naïve about what he might do to get it sold.

I realize now that Larry Gagosian is the most driven, ambitious person I have ever met. He was a kind of Zen teacher who showed me what raw greed and ambition look like in human form. The complicated mixture of contempt and admiration he aroused in me has burned bright in my memory. Honestly, I never thought Larry would

find himself at the pinnacle of the art world or anywhere close—he seemed too deeply flawed—but time has shown that I severely underestimated him.

Gagosian, when I began to work for him, was a relatively new but notorious young player on the L.A. gallery scene. After graduating from UCLA in the early 70's he had launched himself by buying posters for two dollars and selling them for fifteen. Recognizing that works of art could also be "flipped" he soon became a dealer. By the early 80's he was reselling blue chip art to almost every major collector in Los Angeles, bringing the next generation of raw talent in from New York by borrowing artists from other up-and-coming dealers including Mary Boone and Annina Nosei.

It was a materialistic, dynamic and confusing time. Reagan was President, MTV and music videos were still new, AIDS was on the rise and cocaine was the drug of choice for affluent Yuppies. The new art was cheap—you could get a nice Keith Haring flying saucer on paper for $1,000—and Los Angeles was about to get its first museum dedicated to Contemporary Art. A veteran artist who I chatted with at an opening told me "The art world has always been crazy, but right now there is a new kind of crazy coming along."

Reading a review of David Salle's show in *ARTWEEK* made me aware of Gagosian Gallery for the first time. I got my job by simply walking into Larry's space on North Almont. My interview, which lasted about three minutes, consisted of mentioning that I had just graduated from Berkeley, was a painter and that I had a Toyota truck I could use to run errands. After a quick appraising glance up from his desk, Larry hired me on the spot. He was about to open a new, larger gallery space on North Robertson Blvd and the extra help (and the truck) would come in handy. My first day was a kind of low-key hazing in which I tried to locate a new office chair to help Larry with his back problems. I think Larry had a good time leaning back in each chair and then telling me "This isn't the one. Go find me a different one."

A few weeks after I was hired Larry opened the new gallery space at 510 North Robertson, a converted auto repair shop with gloss-coated concrete floors, an arched ceiling and fresh white walls. I was soon one of three gallery staffers who sat behind a counter there,

keeping an eye on the gallery and answering the phone. Behind us was a private office, a kind of chilly concrete cube where Larry met clients behind a frosted glass door. We would hear his BMW pull into the lot in the mornings with some anticipation—Larry usually started the day in a bad mood—so we would answer the phones, watch the gallery-goers and hope the office door would stay closed. Then again, when clients came in Larry would brighten up and turn on the charm. It was always interesting to hear the conversations that took place in front of the art and many of Larry's clients would spend time chatting with us at the front desk too: I learned a lot from these conversations.

One of Larry's clients told me "Larry does not have a great eye for art, but he has a great ear." I have had to think that through. It is true that Larry had an instant feeling for what was next in the art world, but I also think he needs to be given credit for having a very quick, open intellect. Larry would sound out all of his staff on what we thought of each show that was hung in the gallery, and he seemed to process it all instantly. I imagine that in New York he took it all in and picked the brains of every collector, dealer and artist he met. Listening attentively was one of his strengths.

Larry's beach home in Venice was full of art books—I still have a book on Post-Minimalism that I forgot to return—and I could see that each time Larry mounted a show he worked closely with the artist, educating himself along the way. Although Larry did not yet have a dedicated gallery space in New York, he spent quite a bit of time at his apartment there, in contact with artists who were gaining notice and who he later brought to Los Angeles. Jean Michel-Basquiat, Eric Fischl, Robert Mapplethorpe and Richard Serra had shows at Gagosian while I worked there. Others, including David Salle, had recently shown there. Kenny Scharf dropped by in his wackily tricked-out 1961 Cadillac and brought in a stack of his cartoon-themed Jetson and Flintstone paintings.

One of Larry's smartest moves was to bring the leading edge of the New York art scene of the early 80's to a new generation of Los Angeles collectors rich with profits from the entertainment industry and real estate development. Eli Broad, Steve Tisch, Douglas Cramer

and David Geffen were all among his clients. Hunk and Moo Anderson dropped by once but never came back.

My truck came in handy for errands, especially delivering art. When dropping off a Basquiat I was able to step inside Stephane Janssen's home in Beverly Hills and glimpse his exotic collection of CoBrA paintings from the early 1950s. At Douglas Cramer's mansion in Bel-Air I contemplated the broken shards of crockery projecting from the surface of an amazing Julian Schnabel portrait while also noticing the enormous bowls of candy everywhere. Entering the late Barry Lowen's home in the Hollywood Hills brought on a feeling of claustrophobia. I had never seen so much contemporary art packed into a small private home. Doing deliveries had its comical moments. I can hardly forget the time a middle-aged movie producer came to the door in an orange speedo.

Art collector Ed Broida's daughter was also working for Larry. She took me to her father's home to see the raw and imposing late Guston paintings that lined the walls. Eli and Edye Broad's Brentwood home jammed with a rapidly growing collection that had outgrown its downstairs living areas. When I delivered Basquiat's *Beef Ribs Longhorn*—which featured a red eyed-bull and the printed inscription *TEXAS $14,000* in its upper right corner—the canvas had to be set in an upstairs hallway. The Broad's maid, who had guided me upstairs, noticed the figure $14,000 and asked me incredulously: "Did Mr. Broad pay $14,000 for *that*?"

Although I had sought my job to be around art and artists, working for Larry was turning into a crash course in people, power and money. Larry's clients were also looking for more than just art. They craved the excitement of working with a "bad boy" art dealer. Working with him meant not only being around a brash, audacious, young dealer, but also that you might be offered an unexpected treasure at a price that took your breath away.

Among the realizations I was beginning to make was that Larry didn't really treat his clients simply as clients, but as partners. Although he has said in interviews that he has "never had a partner" Larry certainly had very tight relationships with a powerful circle of collectors, and no dealer had ever worked harder to drive up the

prices of the art they already owned. He sucked people into his favorite form of intimacy—the business deal—and gave them the ride of their lives. I think he also leaned quite a bit from his clients on both coasts. How else could he have become an art dealer who understands money as well as a New York hedge fund manager and the star system and branding as well as any Hollywood producer?

Larry recognized that everything is for sale when the price is right. With that in mind, he didn't need exclusive contracts with artists but instead sought out relationships with other dealers and collectors. What I have heard said about Frank Lloyd Wright's relationship with his clients—that at first he worked for them, then they worked together and finally the clients were working for Wright—describes some of the relationships I witnessed between Larry and his clients. Larry acted as if other people's money and art already belonged to him, and this perspective powered his audacious deal-making.

The veteran Los Angeles dealer Esther Robles once told me when she really wanted to sell something she would hang it in her dining room and mention to her guests that it was "not for sale." Larry took this idea to its extreme. Part of Larry's modus operandi was that he considered every collector's dining room—not to mention their living rooms, hallways and bathrooms—extensions of Gagosian Gallery, all ripe with inventory. When I first started working for Larry another employee told me that Larry had just sold a Diebenkorn *Ocean Park* painting right off the wall of Norman Lear's Brentwood home. Larry had recognized that even if you don't own a work of art you can still broker the hell out of it.

I remember one attempted deal that unfolded and failed in less than a day. One morning Larry came with an urgent project: he needed to quickly get hold of a Russian early modern painting that was being exhibited in San Francisco. He wanted it to be shown to the Swiss dealer Thomas Amman who was in Los Angeles for a brief visit. I volunteered to get on the next PSA flight, and by lunchtime I was in San Francisco unscrewing the painting from the wall of *Modernism Gallery* while a very sullen art dealer looked on.

I bought the painting a seat on the next flight home, and by the afternoon I was rushing though the lobby of the Beverly Hills hotel,

nearly knocking over Elizabeth Taylor in my haste. Mr. Amman, who was just packing to leave his bungalow looked at the painting carefully and with exquisite manners let me know that the painting "seemed to have been varnished" so he would "pass on it." When I got back to the gallery I found out that the painting's owner—a doctor with financial problems—had been phoning every half hour from the bar at Trader Vic's, increasingly smashed every time he called. Larry had gone home and let his staff take the calls.

Of course there were also lots of quick deals that went well. Shows at the Robertson gallery were usually sold out by the day of the opening, and Larry used the old Almont gallery as a private showroom to make the side deals happen. Something like a Frank Stella relief could easily be sold in one day. With so much money around in Los Angeles hot merchandise could be flipped quickly, often for a breathtaking price. Speaking of hot merchandise, a dealer from New York stole a Basquiat drawing one day, taking if from a plexiglass frame and stuffing it into her purse after I naively let her into the back room alone. After discovering the theft Larry glared at me for about three seconds—wondering if I was the culprit—and then broke into a grin when he realized who the thief actually was. I don't think he did a thing about it.

It shouldn't surprise anyone that Larry could be quite rude. What puzzled me was that his rudeness was often tolerated and even enjoyed by his bored clients. Once, after an LA socialite came in and asked the price of an Ed Ruscha painting, we called Larry in New York to get an answer. Larry answered the phone in a nasty mood and proceeded to let loose with a string of foul language and a few insults aimed towards the woman at the counter. She could hear the phone conversation and didn't even flinch. In fact, she began to smile. The only way I could make sense of this was to realize that since she was often around obsequious people, Larry was in some way refreshing. After this and a few other incidents I gradually came to understand that wealthy people are often deeply masochistic.

Larry accepted, even embraced the fact that people found him an asshole. A woman who later worked for him in New York once told me "During my job interview, Melissa Lazarov told me—in front of Larry

who nodded in assent—'Larry is a total fucking asshole. If you cry easily or can't take abuse you will not last here.'"

Tantrums were a regular occurrence at the gallery. I remember Jean-Michel Basquiat laying into a graduate student who interviewed him on the phone and asked him "Do you think of yourself as a graffiti artist?" Richard Serra had some choice words for a photographer that didn't follow his instructions in photographing his installation. When the yelling match died down, the photographer peeled out of the parking lot in his vintage Mustang, and Richard turned to the gallery staff to ask; "Was I too hard on him?"

Larry had a trenchant sense of humor, and he could break the tension with a dark remark. I couldn't help but laugh when he quipped that another local dealer "Only knew about jerking off and white wine." A great deal of laughter came from behind the glass door of Gagosian's office as he worked his charm on clients. He was—among other things—quite the entertainer.

The people-watching at Gagosian Gallery was first rate. Robert Mapplethorpe—dressed in black and wearing a cape—as he surveyed his own show without saying a word. Steven Martin and Rob Reiner came in together one day, and Steve ironically mocked the nudity in Eric Fischl's *Old Man and the Sea*. A notable LACMA curator strolled in one day with her German Shepard. When the dog walked towards a gallery wall and began to lift his leg I nearly lost it, but she called him back and avoided an incident. I remember thinking that the curator had acted like she owned the gallery, which was pretty breathtaking to me. Others I remember dropping by included Sam Francis—who was after some money Larry owed him—and also David Hockney who pretty much talked Larry's ears off one afternoon.

I will never forget the Texan with a gold Rolex who came in with his glamorous blonde wife to see a Basquiat canvas of a boxer that was mounted on a stolen supermarket pallet. He wanted to buy it—after being told it would be a great investment—but she found it repellent. Larry was away from the gallery when this happened so the gallery staff simply stood back and let the couple stare and talk. Their conversation, which rapidly grew into an argument, was tense and hilarious. In the end, she won.

Gagosian's staff and entourage formed a kind of family for him. Larry never mentioned his parents, although another gallery staffer told me that his mother worked as a sales clerk at a nearby Robinson's department store. Maybe it was misplaced, but Larry could be fatherly towards his employees, and I appreciated it when he once bought me a new set of tires for my truck. A young D. J. named Matt Dike was often living at Larry's beach place, and I thought of him, and Jean-Michel Basquiat who also stayed at Larry's place, as Larry's troubled sons. Melissa Lazarov, Larry's most loyal employee, was teasingly called "Mrs. Gagosian" behind her back. Larry's relationships with women seemed fleeting and relegated to the background of his life. Business was his favorite form of intimacy.

Larry definitely had some enemies. One night after I picked him up at LAX, Larry seemed nervous about entering his house alone. He had me go in first and check everything out. Once when a young man with long hair walked into his office by accident—thinking it was a gallery space—Larry looked visibly shaken. I remember wondering if Larry thought someone had ordered a hit on him.

There were moments when it was fun and even glamorous to work for Larry. At the end of March, 1983 I attended a dinner ("vernissage") Larry gave at chef Wolfgang Puck's new restaurant *Spagos* honoring Basquiat. "This is the kind of evening you wish the Los Angeles County Museum would have," raved dealer Irving Blum to George Christy of the *Hollywood Reporter*. The Pop artist Roy Lichtenstein and his wife Dorothy were there and so was the MGM Musical star Gene Kelly. Numerous art world power types were in attendance, including a host of Larry's collector/clients, the local director of Sotheby's and a critic from *Art in America*. The food was great, but I spent most of the evening listening to a collector's boyfriend deliver a detailed monologue—Edith Bunker style—describing the flooring being ordered for their sprawling new home in Santa Barbara.

One frantic afternoon I was told to deliver a Basquiat painting to an executive at Paramount. In my haste I threw the painting into the back of my truck without roping it down. A few minutes later, as I was driving, a gust of wind lofted it into the air like a kite. I watched in my rear view mirror as it wobbled in the breeze and then settled onto the

double yellow line in the middle of La Cienega Boulevard. I had seen many drawings on Basquiat's studio floor with footprints on them, but I think Larry would have minded tire tracks. I slammed on the brakes and rescued the painting from oncoming traffic. It was no worse for the wear. A week later, when I used my truck to pick up a repaired Warhol *Hammer and Sickle* from restorer Denise Domergue—it had been pierced by a falling Dan Flavin a year before—I was careful to tie it down. The painting had been through enough already, and I didn't want to risk bringing Larry a Warhol with tire tracks on it. Then again, that might have been really entertaining.

During my final month at the gallery I witnessed the installation of a massive pair of nine-inch thick squares of battleship armor into steel channels that had been inserted into the gallery's floor. Titled *Bilbao*, it was a work by the sculptor Richard Serra who appeared one day with a crew of riggers from New York. Serra's lead installer, Ray LaChapelle, was a veteran rigger from New York (riggers are crane operators who move heavy items into buildings) who told me that during his rigging career he had broken each of his fingers at least once. He showed me his gnarled hands to make his point.

There was considerable drama during the installation. At one point a crane carrying one of the slabs broke through the asphalt of the gallery's parking lot. While he was in town I drove Richard Serra to the home of collectors Elyse and Stanley Grinstein and had a wonderful conversation with him about his views on art. He told me that one of the most influential works in his life and career was Matisse's large *The Dessert: Harmony in Red* from 1908. Serra explained that Matisse's willful decision to repaint what had been a nearly all blue painting with red at the last moment was a lesson in artistic decisiveness and power.

When the Serra installation was complete I told Larry that I would be leaving the gallery. I had grown tired of the machinations, tantrums and frantic pace. Larry had sensed that I was on my way out and had already interviewed Andrew Fabricant who would replace me. The next day I installed a show for Riko Mizuno—a dealer just down the street—who poured me a cup tea and gave me kind of sympathetic exit interview. Wanting to be helpful, Riko called Julia Brown, a curator at

the new Museum of Contemporary Art and got me a job on the MOCA installation crew.

It amazes me to look back years and think that the Basquiat painting that lofted out of my Toyota truck on La Cienega Blvd is now worth twenty times more than what I earned in my entire career as a college professor. Equally amazing to me is the fact that the French Government has given my former boss the insignia of Chevalier de la Légion d'Honneur. Don't knights of the Legion of Honor pay their liquor bills on time?

The way I see it now, Larry was a great teacher in the sense that he was a kind of negative role model. Sometimes the very best lessons come from people who show you what you shouldn't want to become. For my part, I apparently made a less than memorable impression on Larry. In a 2012 profile in *INTERVIEW* Magazine Larry recounted that "There was a guy named John Seed, who was Jean's assistant and he was, like, our cook. He was a great cook." Perhaps Larry's memory has grown fuzzy over time. I drove the truck, made stretcher bars and learned invaluable lessons about art and life. Wolfgang Puck was the one who did the cooking.

Originally written for the author's website in 1997.

THE ANGRY ONE: JEAN MICHEL BASQUIAT

Basquiat's Venice Studio

When I met Jean-Michel Basquiat (1961-1988) in the fall of 1982 he came to the door naked. Just a few days before I had been hired by art dealer Larry Gagosian and had seen my first Basquiat Painting—*Skull*, now in the Broad Collection—at his gallery on North Almont Drive. Larry had explained to me that Jean needed some help around the studio.

Jean had probably just woken up—it was early afternoon—and led me into his studio living space while wrapping himself in a towel. He was living and painting in a former gallery space that had only two pieces of furniture: a mattress with no box spring and a small TV set with rabbit-ear antennae. As I later learned, Jean had once lived in a

cardboard box in a New York park, so he was no stranger to living sparely. I found out later that he was paying Larry $2,500 a month in rent, and he certainly could have afforded more furniture had he wanted it.

The floor was covered with an amazing array of clutter. There were art history books, cassette tapes, art supplies, and clothing including several paint-spattered Armani suits that I later took to the dry cleaners in a plastic garbage bag. There were also drawings on the floor —many with footprints on them—and art supplies including oilsticks, paintbrushes and rollers, some of which were covered with formations of dry paint. On later visits I saw baggies of marijuana and wads of stray cash.

Jean-Michel never drove that I knew of—an ancient Dodge he had driven to L.A. with his friend Stephen Torton had been stolen. I began to go over often, first to deliver the stretchers for him to paint on and later to pick him up to run errands. Generally, Jean sat in my Toyota truck looking sullen behind dark glasses, speaking only to direct me to the next destination.

Jean was a big spender. When Madonna, just at the beginning of her celebrity, came from the East Coast to visit, I took him to the bank to get $5,000 cash. It was meant to be his pocket cash for the weekend. Another time, we walked into a local paint and hardware place and cleaned out the art supply section. Jean-Michel paid by tossing random piles of big bills on the counter so that the stunned cashier could do the counting. I also remember him buying a hundred dollars worth of Neutrogena soap at a Beverly Hills drug store.

On one errand I took him to the office of a doctor who was also an art collector. Jean was being treated for an STD and had arranged to pay for his treatment with drawings. On the way home he asked me to stop at a sandwich place he liked in Beverly Hills. He got out and told me to just take a spin around the block and pick him up.

I got stuck in heavy traffic, and it took 20 minutes to get back. When I got there he didn't say a thing—he was clutching a sandwich and glaring at me from the curb—but three weeks later he walked up to me and gave me an utterly detailed description of how I should have

taken certain back alley and used a less busy street. He included street names and knew where I should have gone right, and where I should have gone left. Incidents like this introduced me to Jean's intensity. Jean could remember details of all sorts and spew them out with real conviction at any moment. In many ways, this is what his art is about: intensely felt but fragmented experience and knowledge.

Jean's heavy spending alarmed and amazed me: I had never seen anyone spend so much money so freely. Wanting to help, I told Jean that he needed to make investments and that he ought to get a stockbroker so that if his career burned out he would have some money put away. He was furious, and immediately explained that there was absolutely no need for him to plan for the future. In his mind a star never had to worry about money, and I had insulted him by inadvertently suggesting that someday he his paintings wouldn't leap off the gallery walls.

After that I began calling him "Elvis," which was my way of kidding him about his drug use and heavy spending. In response, he came up with *White Sambo Gringo*, a jab back at me: his errand boy and chauffeur. A friend later suggested that if I ever made a film about my experiences with Jean it should be titled *Driving Mr. Basquiat*, a kind of racially reversed version of *Driving Miss Daisy*.

My other job, besides taking Jean out to buy art supplies and run errands, was to build stretcher bars. After adding canvas and priming them—some with white gesso and some with black—I would leave them leaning against the studio walls, ready for Jean's late night painting sessions. Among the canvasses I made, following instructions that Jean sketched on the back of an envelope, were several triptychs, joined by Douglas fir 1" x 2"s and braced with plywood triangles made from shipping crates that had arrived at the Gagosian Gallery. One of these became *The Horn Players* in the Broad Collection. Working in my parent's garage I also made a series of large square canvasses, one of which became *Hollywood Africans*, now in the collection of the Whitney Museum. When Jean's one-man show opened in March of 1983 all but two of the works on view were painted on the large stretcher bars I had been making.

Jean Michel, contrary to what you might think, absolutely did not consider himself a graffiti artist. He had friends like Ramelzee who did use that phrase to describe themselves, but Jean hated it. He once hung up on a graduate student who while interviewing him insisted that he was part of the Graffiti Art movement. He felt strongly that he was a fine artist, and his influences ranged from Leonardo da Vinci to Abstract Expressionists like Cy Twombly and Franz Kline. The influence of these and other artists is apparent in his best works.

One day when Jean was away from the studio, I saw a striking five-foot square painting leaning against the doorway and decided I had to have it. Titled *Future Science Versus the Man*, I later learned that it had been in Jean's show at the Fun Gallery in 1982, and that he had brought it to LA where he had added to it.

Future Science was an electric painting, a revenge fantasy meant to mock "white" history and progress as depicted in high school textbooks. It featured line drawings of warplanes, steamboats, Buffalo Bill Cody, a bug-eyed cowboy in a ten-gallon hat, and an astronaut figure whose helmet enclosed a toothy Dia los Muertos skull. It also included words and phrases—carefully printed in Jean's earnest block lettering—including "Radium," "Egypt," and "Fraud 1/2." Underneath a three-pointed crown, a signature Basquiat image going back to his days as the tagger SAMO, the phrase "Ten Gallon" was carefully printed and then crossed out. All of this was displayed on a black and white background that would have made a striking Abstract Expressionist painting, complete with drips. Jean had a way of making images completely his own, and maybe part of what he had in mind was to graffiti over a Franz Kline.

I made a deal to buy the painting with Larry, who must not have told Jean about my purchase. That would cause problems later. I had some money saved, and since I was living at home and not paying rent, I could put most of my salary into payments. I came up with the total of $5,000 in about three months and picked up the painting. My parents were mystified, but there we were, a white middle class family living on the west side of Los Angeles with a Basquiat in the downstairs bedroom. A few years ago, after seeing the designer Valentino

posed with his Basquiat in a glossy magazine spread, my mother sent me the clipping. "We once had one of those in our house," she recalled.

My younger sister with "Future Science" at our family home, 1983

After I took the painting home Jean phoned me several times and insisted that I return it. He said that it should go to a major collector. I wasn't part of the art crowd, and as a social nobody I apparently didn't even deserve to own one of his canvasses. Having grown up feeling excluded because of his race, Jean took a sadistic delight in turning exclusivity around and making it his own tool.

To convince me to let go of the painting Jean offered me a deal. "I have done only two portraits, one of the artist Francesco Clemente, and another of Andy Warhol," he told me. "I will do your portrait, and it will be my third, and I will give it to you." I fell for it, gave the painting back to Larry, and got my money back plus a $500 profit. The transaction made me feel like a slick art dealer for about 5 minutes. The truth was that I was easy to push around. Larry, realizing that it was a terrific painting, used *Future Science* as the invitation for Basquiat's show

It wasn't uncommon for Jean to show hostility towards people who expressed interest in his work. One example of this—which was relayed to me by another Gagosian employee—took place when the wealthy art collector and MOCA founder Marcia Weisman came to visit Jean's studio. When she arrived at his studio he took an immediate dislike to her. As Weisman surveyed Jean's work and surroundings he stayed silent and drew on a large sheet of butcher paper. The drawing, later titled *Ribs, Ribs, Ribs*, depicts a powerful black man wielding a bone. As Weisman was getting ready to leave he added a sticklike penis and testicles to the image and later told a gallery staff member that it

depicted Marcia Weisman. Saying this was his way of shaming a powerful white person by transforming her into a martyr that embodied the curse of black manhood. When *Ribs, Ribs, Ribs* later appeared at Gagosian Gallery in a large frame, two of my co-workers posed for a photo in front of it, mocking its shamanic intensity.

Gagosian employees pose with Ribs, Ribs, Ribs, 1983.

Jean had his big show in the spring of 1983, with the painting I had returned on the front of the invitation. The opening was jammed, and he showed up very late and very stoned, listening to a Sony Walkman. I think he really couldn't handle social pressure. A few weeks later, he went back to New York and moved into a loft on Great Jones Street that he leased from Andy Warhol.

When I got the job of cleaning up after him I found my portrait among the detritus he had left behind. It was painted on one of the cheap canvasses we had bought one day at Standard Brands and had a splashed red circle with crude features—my face—in the center. On the bottom Jean had written my name "John Seed" in oilstick, followed by "White Sambo Gringo" with a red arrow pointing downwards. The arrow, of course, was pointing me down to Hell.

Somehow, maybe by calling him "Elvis" and daring to buy one of his paintings, I had brought out his deepest hostility. Like Marcia Weisman, I had been cursed. The painting made me uneasy enough that I tossed it into the closet and never hung it on the wall. My father saw it one day and asked me: "Why would you want to keep that?" A few weeks later, after I cleaned out Jean's studio for the final time, I sent *White Sambo Gringo* back to Jean's New York studio in a crate along

with other works of art and some personal items. I have never heard of it since and assumed that it went into a dumpster—where it belonged—as soon as it arrived.

Looking back, I remember Jean-Michel as being like two people: a sweet likable one and a damaged, hostile one. He was paranoid about the people surrounding him and was right to be that way as so many people were using him. At least one member of Larry's entourage stole some his drawings, and in a weird way Jean had wanted that. He enjoyed confronting the guy who'd stolen from him and knowing exactly what had been taken.

Putting aside my bad experiences with him, I have to say Jean made a positive impression on me as an artist. He really had what I would call "second nature": his art was utterly direct and in touch with deep emotions. I think of his art as being poetic and also about the alchemy of signs and symbols. He made powerful art about the problems of race, and the sheer vitality of his ideas and imagery continues to dazzle me.

I was very fortunate to know Jean at the peak of his creativity, but also unfortunate to see his growing paranoia and distrust of those around him. When friends have asked me about him, I state that I truly believe that if he had ever been sober for an extended period, he would have needed considerable support and therapy. I understand that several people in his life later tried unsuccessfully to help him. When I knew Jean a lot of money was being made; apparently nobody wanted to mess with the magic, and drug use was a part of that.

Friends have asked me if I regret selling *Future Science Versus the Man*. Honestly, it would be nice to have something worth millions of dollars, but I shudder when I think of the trouble that painting might have gotten me into over the years. Interestingly, it showed up in the news in 2017 after art advisor Lisa Jacobs, who had brokered its sale in 2011, was charged with secretly skimming $1 million of her elderly client's money while making the deal. Basquiat paintings seem to attract trouble.

I did see *Future Science* ten years later at the Whitney Museum's Basquiat retrospective in 1993. My wife offered to take my picture with it, but a hovering guard wouldn't allow it. I didn't bother to try and

explain that it had once hung in my bedroom. The wisdom I gained through knowing Jean has turned out to be priceless, much more valuable to me than any painting. Jean had exemplified something Nathan Oliveira once told me: "Sometimes the great ones are the angry ones."

Originally written for the author's website in 1997, then revised and published on the Huffington Post on July 29, 2010

MOCA MEMORIES: 1983-85

Installing a Giacometti Painting at MOCA, 1983

In September of 1983 I was hired as a member of the installation crew of the not yet opened Museum of Contemporary Art in downtown Los Angeles. Established in 1979, MOCA had been trying for some time to open an exhibition space, and its Founding Director, Pontus Hultén, had recently resigned. Hultén's Volvo, crushed into a cube by the French artist Arman, remained in the museum's Boyd Street offices, and some of his exhibition plans and expansive vision lingered as well. Richard Koshalek, an idea man lured from the Walker Art Center in Minneapolis, had taken over as Director and things were hopping.

For a dollar a year, the city of Los Angeles had agreed to rent

MOCA the building that would be called the *Temporary Contemporary*, a 40,000 square foot industrial building in Little Tokyo. Originally a hardware warehouse, and later an auto body shop, the building was rapidly being cleaned up and sparingly renovated according to plans provided by architect Frank Gehry.

The idea was that MOCA would be open well before the summer 1984 Olympic Games, ready to demonstrate the cultural vitality of Los Angeles to legions of visitors. A permanent building, designed by Arata Isozaki, would follow in a few years. There was a building boom going in downtown throughout the 80's and MOCA was a key element in a surge that was intended to make downtown sparkle.

My first day on the job, Lorraine Gordon, Hultén's former office manager, took a quick Polaroid photo of me, laminated it into a MOCA security badge, and sent me right to work. For a young painter like me, working at the TC—as it was called—was going to be a phenomenal opportunity to become exposed to myriad works of art, as well as an opportunity to meet artists, collectors, curators and their hangers-on. What I didn't anticipate was that my exposure to downtown Los Angeles would leave another set of impressions, many of them disturbing and frightening. MOCA opened up a vivid world to me, but Skid Row, where I would soon rent a loft was even more eye-opening.

The installation crew, half a dozen or so artists and hands-on types led by the unflappable John Bowsher, was preparing to install *The First Show*, a gigantic exhibition featuring major works of modern and contemporary art borrowed from eight private collections. From the moment I arrived until the *First Show* opened in November, the TC was a beehive of activity. Crated art was arriving from all over the world, including giant canvasses from the Saatchi Collection in London that had been inserted into special leaning crates that barely fit into a Boeing 747 cargo jet.

My first glimpse of the museum's director, Richard Koshalek, came when he ordered that a freestanding display wall intended for a hulking Julian Schnabel painting be instantly demolished and then re-erected a few yards away. Koshalek, I would learn, had Pharoahic self-confidence. He was a great guy, but he tended to wear out the people who

worked for him. He liked to state that MOCA, with a staff of around 40 people, was mounting exhibitions that were comparable to those of the Whitney in New York, which had a staff of over 100. If the museum's top administrator, Sherri Geldin, hadn't been there to provide reality checks, who knows what he would have asked us to do.

The Temporary Contemporary, was a soaring, flexible space, and it wasn't the last time that I saw walls fall and rise in a matter of days or even hours. My memory of the period is a blur, but I do remember the fatigue of working long hours interspersed with the excitement of uncrating and installing great works of art. Seeing the vivid lunar blue of Yves Klein's sponge and pebble *Requiem* as it was uncrated was so moving that when *The First Show* was over I took the exhibition label home as a relic and pinned it to my wall.

After a few months of working there I had given MOCA my own nickname: "The Museum of Coffee Achievers." Like myself, most MOCA staff members were young, few had children, and we all understood the price of working at such a great place was the total dedication it required. It made sense that I should try to find a place to live near the museum, and I had the romantic idea—very much in line with the vision of MOCA's founders—that downtown Los Angeles was going to be the next SoHo. I would be like a New York artist, living in a loft, imbibing culture, and waiting for gentrification to hit.

Fearlessly, I rented a two-room loft space in "The Birdhouse," a former Canadian Embassy building at 432 S. Main Street about a fifteen-minute walk from the Temporary Contemporary. The building's nickname, I was told, came from the fact that until a few years before, the only tenants had been flocks of pigeons. For about $350 per month I got high ceilings, aged hardwood floors and even a kitchen sink. The shared bathroom was down the hall, and my parking spot was on the roof of the Greyhound Bus terminal a few blocks away. After finishing grad school I had moved back in with my parents, and I was anxious to have my own space again, however gnarly it was.

Before signing the rental agreement for the studio I hadn't thought too hard about the neighborhood. Getting to know it was a reality check. At street level there was an adult theater and a pathetic little market that sold dollar wine. My loft was on the third floor over the

alley in back, so at least I didn't have to listen to the sad, grinding soundtracks of the porno movies as those living on the second floor did. Of course, that might have been preferable to living over the alley. As I soon learned, the building behind the Birdhouse was a shelter for American Indians, and I soon became accustomed to the screams of the angry drunks who pounded at the locked front doors late at night. The other Birdhouse tenants were artists and architects, but the Union Rescue Mission was just a block or so away. Flophouses and wholesale toy stores lined the nearby streets, which were peopled with impoverished immigrants, ex-cons, transients, mentally ill Viet Nam veterans, and drug addicts.

I moved into my new loft quickly, as I had little furniture except for a particleboard desk and a used sofa provided by my parents' next-door neighbors. Soon I had a routine, leaving the building at 8AM to make the 15-minute walk to MOCA. Often there were drunks passed out by the entrance, and the same two tough looking women flanking the front door. I was innocent enough that I had lived in the building perhaps a month before I realized that the women—whose features resembled those of ancient Olmec heads—were prostitutes. The front steps always smelled of stale urine, and were often littered with shards of broken glass. It was weird to walk by all the beer and wine bottles in the gutter and then arrive at work where Jasper Johns's bronze *Ale Cans*, insured for a quarter of a million dollars, were secured in the plexiglass box where I had placed them with white gloves.

On weekends, I would explore the nearby streets and take in a movie on one of the dilapidated movie palaces on Broadway. Panhandlers were everywhere, so I took a practical approach and carried quarters every morning to give away. When I ran out of change, I learned that if I stared at my feet and strode with purpose I would be mostly left alone. I should have been more scared of my neighborhood, but naïveté protected me. The streets surrounding the missions on Los Angeles Street teemed with homeless men and bag ladies. Every day I saw men passed out on blankets on the sidewalk or peering from cardboard boxes. One day a frustrated panhandler approached me while I was carrying a Coke away from McDonalds and grabbed it out of my

hand. He slammed it into the sidewalk and glared at me. "I want some," he muttered, and walked away.

Once, when leaving the Birdhouse through the side gate, I managed to be a hero. Noticing a man running up Winston Street with a purse under his arm, I found my deepest voice and yelled "Drop it!" The man followed my direction and then scrambled down the alley behind my building. Moments later a grateful elderly lady told me, as I handed her purse to her: "Good cop voice." I used the same voice a few days later when a man opened the passenger door of my truck at a stoplight and asked for a dollar. It was scary, but a strong "No!" sent him packing.

Getting to know downtown wasn't all about fear: downtown food could be a pleasant surprise. The omelets at Gorky's, a Russian-themed café near the downtown flower market, were topped with sour cream and caviar. I don't think Stalin would have approved. On Second Street there was a Mexican seafood place where I would order a single deep-fried fish, served surrealistically atop a mountain of fries. Best of all, right around the corner from the TC was the Far East Café, an archaic Chinese restaurant hanging on in Little Tokyo, where the black mushroom chow mein had a distinctive, smoky flavor.

At the TC, I soon had a new job as the supervisor of the information counter where volunteers greeted visitors and sold exhibition catalogs. As I gradually learned, many of the volunteers were themselves art collectors, and most were quite wealthy. They tended to be the wives (and ex-wives) of some of the richest collectors in Southern California. It was a very pleasant job, and I genuinely came to like many of the volunteers. One of them, Yvonne Segerstrom, offered me a ride home one day: she went ashen when she saw where I lived. More and more I was realizing that MOCA was a kind of gated community. The exception tended to be the guards: African-American and Hispanic men and women who lived nearby and found their place of work as weird as a newly landed spaceship.

Living downtown could be funny, in a very dark way. At night I would close my windows but could still hear arguments and tantrums in the alleyway three floors below. There was one man whose distinctive complaint caused me to nickname him "Mr. Nobody Fucks With

Me." Late in the evening I would hear him in the alley, howling a variation on the same sentence, sometimes for hours.

"NOBODY FUCKS WITH MY STUFF!"
"N-O-O-O-O-BODY FUCKS WITH MY LADY!"
"NOBODY FUCKS WITH MY BROTHER-IN-LAW!"

That's right: he was very protective of his brother-in-law.

One evening I heard the wails of a blitzed couple, shut out of the Indian mission, who were having sex on an abandoned sofa in the alley. They were screaming—not out of passion—but because a drunk had set the sofa on fire. After some scuffling and yelping the fire was put out. The alleyway was also used for movie and TV shoots. When I heard sirens, screams and racing motors I never knew if it was a real cop chase or a crew shooting *Starsky and Hutch*. When I heard gunshots, as I did from time to time, I told myself that it must be a TV crew shooting blanks. When I played Italian operas on my phonograph to mask the sounds outside, the screams outside blended oddly with arias.

Work had a touch of Hollywood as well. I remember, for example, seeing George Lucas with his friend Linda Ronstadt admiring Doug Wheeler's light installation. Along with other members of the MOCA staff I was invited to the lavish homes of some of the museum's patrons, including those of Eli and Edye Broad and Marsha Weisman. It was a very schizoid way of living. After attending a holiday party at the Broad's house one evening I parked my truck on the roof of the Greyhound bus terminal and watched the rats dart in and out of the gutters as I warily walked home past the sleeping homeless.

The First Show closed in February of 1984, to be followed by an installation by Michael Heizer and a small show by Robert Therrien. A blockbuster conceived by Pontus Hultén, *Automobile and Culture*, ran for six months beginning in July, entertaining and perplexing crowds of visitors to the Summer Olympics. My duties shifted once more, as a new bookstore had opened in the front of the TC and I became the manager. We did very well selling *Automobile and Culture* t-shirts with the ignition of a '56 Ford silk-screened on to them but could hardly

give away the fancy auto posters designed by Ivan Chermayeff (the designer who famously put the blue "O" in the Mobil logo.)

One thing I often remember Richard Koshalek saying was that MOCA was meant to "extend itself out into the street." This was literally true during the *Automobile and Culture* installation when exotic cars would be parked under the TC's steel canopy for weekend "Street Shows." The weekends brought impressive attendance figures, sometimes over 2,500 visitors, but I have to wonder if they came to see the Lamborghini Countach more than they came to see the art. I thought that the most impressive fusion of art and the auto was Rachel Rosenthal's mesmerizing *KabbaLAmobile*. On a podium rising from the downtown Department of Water and Power parking lot, Rosenthal chanted amplified 12th century Kabbalistic poetry while a seven car precision driver team, known for their work on James Bond films, traced patterns around her with eerie symmetry. The sounds of the performance—Rosenthal's incantations, along with the racing motors and squealing tires—were like the sounds I heard in the alley at night, refined into culture and transformed into a prayer.

It was during this period that I had my first one-person painting exhibition at Newspace Gallery in Los Angeles. My paintings, which featured traditional subject matter charged by heavy brushwork, had nothing to say about where I lived. Kitty Morgan, who reviewed my show for *ArtWeek*, interviewed me in my studio and then brought up the following question in her review:

> *"How can a contemporary artist living in downtown Los Angeles, who each morning picks his way through empty Night Train bottles on his way to MOCA, paint lovely pictures?"*

It was a good question. The painting that appeared on the invitation to my show did in fact feature empty wine bottles, but they had once held Chardonnay and Merlot bought at Trader Joe's in Pasadena, not Night Train. I had tried painting downtown, but the results weren't strong. The one Los Angeles painting that I still have a photo of is chaotic and cartoony.

Increasingly, the stress of being between poverty and privilege

every day began to wear me down. I rarely brought friends to my loft: it made them too nervous. When a pair of art dealers dropped by my loft one afternoon they were freaked out and barely glanced at my paintings. One was looking out my windows the entire time, making sure that his Mercedes parked across the street wasn't being broken into.

One morning, on my way to work, I had an experience so powerful, that I still can't entirely deal with it. Walking along Los Angeles Street I saw a blur falling from a second story window maybe forty feet away from me. It was an infant. In a rush of adrenaline I averted my eyes and heard a sickening thud on the sidewalk. The street was crowded, and as I tried to keep from vomiting I remember thinking how glazed everyone looked. The people on the street were barely reacting. A cop pulled up, the crowd grew larger, and I asked myself if I had really seen what I thought I saw. To this day I still can't call up the details in my mind, but I know what I saw.

In the spring of 1985 a sculptor who worked on the installation crew told me I could lease an upstairs apartment in a small industrial building that he owned at 37th and Main. The neighborhood was an improvement, although the backyard fence did have razor wire around the top. It was great to have a full kitchen and my own bathroom, and the backyard made it possible to have a dog. I named my mixed-breed puppy "Turrell" after James Turrell who would have a memorable exhibition at MOCA in the fall of 1985.

As my living situation became more conventional, MOCA was also moving in a more conservative direction. In early 1985 the museum exhibited a group of works, purchased for 11 million dollars from the collection of Count Panza di Biumo. I remember wondering why modern works by New York artists belonged at MOCA when there were living California artists well worth collecting. In my mind, the Panza collection featured works that would have fit in better at another museum devoted to modern art. That said, once the Panza show was hung my reservations faded. Before work I would sip coffee in front of the magnificent room of Rothko paintings that were the centerpiece of the Panza Collection. The emptiness of Rothko was another escape from the wilderness of downtown life.

My apartment at 37th at Main showed the influence of working at MOCA. All the walls were gallery white, and in my dining room hung an emerald green Eric Orr painting: a kind of cousin to the blue Rothkos I admired at work. When I walked Turrell, it was in a light industrial zone with a mix of businesses, dilapidated homes and a Mexican market. It was safer, but still a long way from the west side of L.A.

My place wasn't too far from the USC Campus, and one early morning while walking Turrell I saw a bus pull up in front of Sorority Row. As the passengers spilled out, I saw that they were young men in tuxedos and girls in formal dresses, just back from an event that must have gone all night. One girl tripped on the curb as she left the bus and began to vomit. Then, in a kind of chain reaction half a dozen of the young, beautiful USC students began to vomit onto the sorority house's manicured lawn. If you were to ask me what I remember about the Reagan years, I would tell you that there was heavy drinking on Skid Row and Sorority Row. Of course, I would also tell you that it was a very exciting period in the art world.

The MOCA Bookstore

Managing the Temporary Contemporary bookstore was an education. One interesting person after another would lean on the counter and chat about art. Count Panza, a gracious soft-spoken man, once explained to me that site-specific works had a natural appeal to an Italian, as he had grown up contemplating frescoes embedded in the walls of buildings. Francesco Clemente came in and signed my copy of the *First Show* catalog: before someone stole it, the book had been signed by over fifteen of the artists whose works had been in the show. David

Hockney, wearing mismatched socks, bought a book on late Picasso that he was very pleased to find in our inventory. Paloma Picasso toured the TC with her husband one day, and I remember thinking her exquisitely, exotically beautiful. When the Director of the Picasso Museum—Dominique Bozo—visited, my bookstore staff had a huge laughing jag over his last name, but only after he had left.

One day a sharp-featured older woman—I don't know if she was his wife or his dealer—dragged in an elderly gentleman and confronted me. "This is Rufino Tamayo, the Mexican master," she told me, "and he must have a retrospective here!" I explained that I was only the bookstore manager, but that didn't slow her down: could I please get on the phone and call the museum director immediately. Tamayo looked at me and winked: he didn't mind being her toy poodle and was used to her pitches.

Wonderful small exhibitions complemented the major ones, and during the summer of 1985 I found Bill Viola's *Theater of Memory* mesmerizing. A crew managed by John Bowsher—who later engineered the installation of Michael Heizer's massive boulder at LACMA—managed to drag a thirty-foot tall, uprooted magnolia tree into one of the upstairs galleries, where it was hung with lanterns and hundreds of silver wind chimes. A fan activated the chimes while a large video projection crackled and bristled with fragmentary images. It blew my mind. Why, I wondered, did the museum need a fancy new building on Grand Avenue, when the TC could facilitate installations like this one?

During my final months working at MOCA, the TC was the site of a memorable show and installation by James Turrell, an artist who works with light, space and perception. I was in awe of Turrell's work, and felt that his show was exactly the kind that could only be presented in a place like the Temporary Contemporary. Exhibitions like Turrell's were one reason why working at MOCA was just wonderful. Another reason was the supportive atmosphere: when Richard Koshalek came to a staff meeting one morning and read part of an LA Times review praising one of my paintings, it made me feel included.

The museum's new Grand Avenue building was nearly completed, but I felt ambivalent about the possibility of working there as I had

bonded with the TC. Add to that, Stuart Buchalter, a trustee who was helping with the development of the new bookstore, was an expert in cost control. He decided that a whopping $17,500 would be the perfect annual salary for the Grand Avenue bookstore manager, and I choked on that figure. By offering me such a tiny salary Mr. Buchalter did me a favor, helping me realize it was time to move on. The bookstore employees gave me a going away party at which one of them—Mike Lynch—presented me with a cartoon that showed me speeding away from a crowd of "well-meaning MOCA-ites," towards a life of painting, personal glory and mountain top meditation.

John Seed Comics, by Mike Lynch

Originally written for the author's website, 2003

F. SCOTT HESS: A CONTEMPORARY REALIST

F. Scott Hess, 2012

I first met Scott Hess in 1984 through my friend and fellow artist Peter Zokosky. At the time, Peter was living and working in a converted storefront in mid-city Los Angeles, just north of La Brea and only a few blocks away from Roscoe's Chicken and Waffles. Peter had discovered the neighborhood—a historically African American area that had so far escaped gentrification—and when artist Kerry James Marshall moved out, Peter recommended his vacant loft to Scott, who promptly moved in.

One evening Peter took me over to meet Scott and his girlfriend

Gita and to see Scott's work. I was impressed and even a bit amazed by what I saw. His paintings were ambitious and mesmerizing to the point that I hardly knew how to respond to them. Even though the paintings were set in Los Angeles, they didn't look a bit like anything else being painted there at the time.

Scott's works were powerfully realized, highlighting his ability to render groups of figures in complex poses and emotional situations. They were representational paintings with roots that led back to old master paintings and to Viennese Expressionism. It wasn't just that Scott had exceptional natural gifts; it was immediately clear that he had been given the kind of training in drawing that was very difficult to find in the United States. Many of the professors who trained American artists in the 1970s had been abstract expressionists, and few were equipped or inclined to teach traditional figure drawing. If you wanted to learn to "draw," you had to major in illustration or hire a model and do what you could to teach yourself. Even in Vienna, Scott remembers having a "drunken abstract expressionist" as one of his life-drawing teachers.

Zokosky, who had worked closely with art restorer Richard Saar, was also creating representational paintings that demanded the mastery of arcane skills. As one would expect, during the years that they were neighbors, Scott and Peter looked hard at each other's work and developed a strong sense of camaraderie. "We were struggling to make some kind of mark, but enjoying the freedom that comes from neglect" is how Peter remembers it.

Scott, Peter, and the tight circle of representational artists that they drew and socialized with over the next twenty years were definitely working against the dominant trends that were in vogue at the city's art schools, galleries, and museums. CalArts, where conceptualism and European theory were the hot tickets, was Los Angeles's leading art school, and Light and Space was still the city's only widely acknowledged movement. The curators at L.A.'s new Museum of Contemporary Art, which opened in time for the 1984 Olympic Games, showed little-to-no interest in the city's emerging representational painters.

Despite its new contemporary museum, Los Angeles was still

widely seen as a second-rate art city, and any California artist who wanted to climb to the top of the art pile had to move to New York or at least show there. The experiences I had in L.A. before and during the time I knew Scott, including working for an art dealer and as the bookstore manager at MOCA, gave me a context that helped me appreciate what made him a unique figure in the L.A. art scene.

In 1983, the year before I met Scott, I had worked as an installer for Larry Gagosian, a fast-rising young dealer who was introducing a new generation of New York art-stars-in-the-making to the L.A. scene. One of the first shows I hung was works by Eric Fischl, a CalArts graduate whose edgy representational paintings dealt with sexual tension and revelation in a clunky, self-taught style. Looking back, Fischl had a great deal in common with Scott, but the similarities end with any comparison of their technical skills. Fischl is and was a "bad" painter whose technical naiveté has often been justified as adding a kind of authenticity to his work.

As I got to know Scott better, I learned that he had left his native Wisconsin after college and spent close to six years studying at the Academy of Fine Arts in Vienna. While there he had gained exposure to Northern traditions and methods, studied European old masters, and come into direct contact with the lingering traces of Vienna's fin-de-siècle morbidity and eroticism. No wonder he was so different. Scott told me many vivid stories about his studies with the "psychic realist" Rudolf Hausner in Vienna, and about his training in academic painting techniques. Some of the stories, like the description below of an anatomy lab he attended in Vienna, may have actually been true.

> *The anatomy professor had an assistant, who was hunchbacked like Igor in the Frankenstein movies. Whatever part of the body we were studying, say the leg, Igor would wheel in a gurney stacked with them and each student got one to draw from. They'd been picked over pretty thoroughly by med students, and weren't all in the best of shape. The most memorable day was Igor wheeling in a cart of skinned babies. We each got one to draw. Needless to say, if you learn anatomy by this means, it sticks.*

The paintings that I saw in Scott's West Washington loft were

about American life, particularly life in Southern California, observed through an acute and jaded sensibility. They depicted social gatherings—studio parties and backyard barbecues—in a style that was emotionally claustrophobic and expressively tinged by garish contrasts of color and lighting. *Xmas BBQ* from 1985 is a send-up of the tradition of Christ in the Manger pictures, with the grill's embers replacing what would have been the light of Christ in an old master picture.

During a visit to Scott's studio in 1987, I saw a new picture that left me delighted and a bit flabbergasted. *Sudden Storm*, which is roughly 7 feet tall and 10 feet wide, features a crowd of more than 200 figures—led by Mickey and Donald—fleeing down Main Street of The Happiest Place on Earth as a curling black thundercloud gathers force over their heads. The painting was, and still is, very, very funny and very, very menacing. It was Scott's apocalyptic revenge fantasy on an entire culture. Scott actually loves California and its culture but acknowledges that he has "a funny way of expressing it."

Around the same time that I saw *Sudden Storm*, I moved away from Los Angeles to take a full-time teaching job at Mount San Jacinto College. Scott and I remained loosely in touch, and he had a small one-man show at MSJC that included some of his Viennese student works: I remember a lot of fierce flying pigs. Scott earned good money in the late '80s and had a waiting list for his paintings. He was able to purchase a home in Echo Park, marry Gita, and welcome two daughters into the world. Although he was enjoying true "bourgeois" success, his paintings lost none of their edge. When he lent my college gallery a view of Echo Park for a group show in 1989, its flickering acid-trip lighting and wavering palm trees were more than our gallery director could easily handle. She told me that the painting "freaked [her] out."

Meeting Scott showed me the power of narrative painting to depict and generate a powerful range of emotions. There is a level of emotional truth in his work that I found extraordinary. Today, I still do.

Excepted for an essay contributed to the book F. Scott Hess, published by Gingko Press in November, 2014

NATHAN OLIVEIRA: FORGETTING THE SELF

Nathan Oliveira by Mimi Jacobs, 1976

To study the self is to forget the self. To forget the self is to be actualized by myriad things. When actualized by myriad things, your body and mind as well as the bodies and minds of others drop away. No trace of realization remains, and this no-trace continues endlessly.
 - Dogen (13th century Zen Master)

The cover of the exhibition catalog *Nathan Oliveira* by Peter Selz displays what California art lovers would recognize instantly as a "classic" Oliveira canvas, *Standing Man With Hands in Belt* (1960). Like so many of the large oils that first brought Oliveira's work recognition it contains a single figure set in and against a field of painterly gestures, fields, drizzles and drips. Inside the catalog, a full page is reserved for the dusky *Spring Nude* (1962) in which a seemingly weightless female evanesces from a salmon pink mass of glowing, calligraphic brushwork.

Paintings like these, which Oliveira executed between 1957 and 1962, when he was in his late twenties and early thirties, brought him early recognition, but also created the public perception that Oliveira was only a "figurative" artist. He was seen as a late-joiner to the Bay Area Figurative School, and it is true that he attended drawing sessions with its members including David Park, Elmer Bischoff and Richard Diebenkorn, who became a lifelong friend. The problem with this association, and with the early fame achieved by the artist as a young man, is that his approach to the figure was fundamentally different from that of the other San Francisco Bay Area artists.

Oliveira has persistently used the figure as the starting point for his artistic process but not as its true subject. Something similar could be said of his animal images, his sites and fetishes of the late seventies and also of his recent *Windhover* series. They appeal to the imagination while resisting easy classification or interpretation.

The constant feature of Oliveira's creativity is that he has been trying to forget his subjects, not to paint them. It turns out that an artist famous for his figurative work has been working towards abstraction all his life. His work portrays the struggle of the artist's self and its consciousness to move towards a connection with the universal and the eternal. It is a struggle that begins with the perception of self and others, and which ultimately moves towards abstraction and destruction of those perceptions.

Oliveira's real subjects are human presence and absence.

When Oliveira's work gained national attention in the 1959 *New Images of Man* exhibition at New York's Museum of Modern Art, the world was still absorbing the horrors visited on the human body by the Holocaust in Europe and the use of nuclear weapons in Japan. In this

exhibition, Oliveira's paintings were shown alongside those of leading Europeans including Alberto Giacometti and Jean Dubuffet who were creating images of the human figure that attempted to suggest the perilous condition of human beings in what seemed a bleak and Godless future.

This tone is apparent in Peter Selz' introduction as he discusses the work of Dubuffet:

> *His treatment violates all sacred and dearly held concepts of mother, wife, lover, daughter and sister, as well as the principles of beauty derived from cultural signals of the erotic.*

The European philosophy of Existentialism had given its permission to artists to treat the body in a radical new way. The philosopher Jean-Paul Sartre had set the unsentimental tone.

> *Indeed, everything is permissible if God does not exist, and as a result man is forlorn, because neither within him nor without does he find anything to cling to.*

During the same decade when Europeans painted the body to suggest the despair of this condition, the American phenomenon Jackson Pollock one-upped the Europeans by eliminating the body from his art altogether and using dripped skeins of paint to project anxieties that were deeply personal and abstract. Just as America emerged from World War Two as the world's leading power, New York surpassed Paris as the center of modernism and abstraction won the war of modernist styles.

To understand how Oliveira became an artist and to appreciate how quickly his ideas developed, it is necessary to consider the influences that shaped Oliveira as he grew up 3000 miles from New York and even further from Europe.

As a high school student first studying painting he had been thunderstruck by a Rembrandt portrait, *Jooris de Caulcerii* (1632) in a San Francisco museum. Although Oliveira had grown up in a Portuguese Catholic household, Rembrandt was one of the first of a long line of

Northern European, Protestant artists who would speak to him through their artwork. Rembrandt was the first major European artist to plumb the self as artistic subject matter, and the artist's anxiety and self-doubt were his gateway to profound realizations about personality and spiritual doubt. Rembrandt, with his Protestant anxiety, offered a way of coping, through art, with a modern world that had just begun its slow divorce from the rituals and rites of Catholicism, still tinged with helpful Pagan magic and the promise that an appeased God could protect those who renounce sin.

Oliveira must have recognized a particular aliveness in the Rembrandt portrait. It was the aliveness of an individual man living with the anxiety and promise of a world where Calvinist thought suggested that the face of God could be glimpsed through contemplation. Rembrandt, Oliveira realized, was a kind of master magician who could conjure up this aliveness of the self through the inherently abstract medium of paint strokes on canvas. It was as if an artist who had been dead for over 300 years had reached out through the canvas and handed Nathan the brush, and said: "Why don't you see what you can do with this?"

Although it was the representational art of Rembrandt that woke Oliveira up to the possibilities of painting, abstract art was a powerful force in the San Francisco Bay Area. When Oliveira enrolled in the California School of Fine Arts in 1947 Clyfford Still had been on the faculty for a year, and Mark Rothko was a summer instructor. The influence of abstraction was so powerful that by 1949 the *San Francisco Annual Exhibition* was made up almost entirely of abstract art.

At this same time, a powerful countercurrent of Northern European art came to Bay Area in the form of exhibitions at the de Young Museum of Max Beckmann (1949), Oskar Kokoschka (1950), and Edvard Munch (1951). All three of these artists were Expressionists who relied on the storytelling possibilities of figurative art, and one of them, Max Beckmann, came to San Francisco in 1950 to teach a summer painting class which Oliveira enrolled in.

To study with Beckmann, who disliked abstraction and called it "nail polish," was a challenging, stimulating experience for Oliveira. Some art historians have argued that the vogue of Postwar American

abstraction was a kind of avoidance of historical content, and since the horrors of the holocaust and Hiroshima were honestly portrayed by photojournalism, Expressionist art seemed to have been outstripped.

Beckmann, who spoke little English, was nonetheless a compelling teacher whose very presence was a reminder of the vitality of European painting traditions. He was a fully committed artist who had endured the humiliation of Hitler's *Degenerate Art* exhibition, and a poignant exile from the vanished world of German Modernism.

As Oliveira later recounted:

He seemed like a very fundamental man, whose only interest was in painting—that's all he wanted to do. Still, I think from our encounters he communicated, indirectly, what artistic values were about.

By the time Oliveira graduated from art school in 1951 he had already been confronted by the powerful artistic traditions that he had spent his career integrating and resolving: figuration and abstraction. His exposure to Beckmann's work had convinced him that painting needed to tell a story, but the pull of abstraction would take his narratives into new, difficult artistic territory.

American Abstract Expressionism, or "Action Painting" as critic Harold Rosenberg called it, was a style of painting that involved improvisation. It had taken New York by storm in the late 1940s and early 1950s and it was the style that any "advanced" artist on either coast had to adopt or risk being called academic.

One Abstract Expressionist—Willem de Kooning—who Oliveira met and befriended in 1959, liked to call himself a "slipping glimpser." Originally trained as an academic artist in Rotterdam, de Kooning became famous for his series of *Women* which were everything but academic in their painterly execution. De Kooning's figures seem to melt into a casserole of drips, ribbon-like paint strokes, and ragged impasto. This violent use of paint impressed Oliveira, but he also understood some of the deep human and perceptual suggestions imbedded in de Kooning's vision.

Oliveira remembers de Kooning telling him how he had once glimpsed an attractive woman at a party. Moments later, de Kooning

recounted, he looked back and found her gone. This, he told Oliveira, was something he kept in mind when painting—the visual memory of presence and absence. Oliveira's *Sitting Man with Dog* of 1957 has a strong kinship with de Kooning. The vivid black and grey swaths of paint which criss-cross this enigmatic figure seem to both give the figure its mass and simultaneously obscure it. The image has a haunting figural presence, but the artist's process suggests that this presence is tenuous. Perhaps it is just the shadow of a man who has vanished.

Just ten years later, Oliveira would again deal with the theme of disappearance, and the clear style of his *Stage Paintings* showed the artist gravitating back towards a world that a viewer's eyes could recognize, albeit an empty one.

In *Stage #2 with Bed* the themes of presence and absence are suggested by an open door and an empty bed. With the earnest intent of showing us that his evanescent world could be briefly focused, Oliveira manages to give us narration, but with only a few recognizable forms. Clearly, what has happened or will happen in this world is a human drama, but the painting demands imagination from the viewer and implies that the artist and his subject have "exited", thwarting easy interpretations.

To put it another way: Oliveira's audience is part of the meditation of presence and absence. As *Stage #2 with Bed* suggests, Oliveira is aware of the audience for his art, but asks them to exit the stage door and go beyond the constraints of what they can recognize.

Oliveira's friend Richard Diebenkorn was also eliminating figures around this same time, starting work on the *Ocean Park* series of abstractions that Oliveira would admire and borrow from. Diebenkorn had grown tired of the way critics and viewers found Freudian and sexual connotations for the figures in his work, an annoyance that Oliveira shared. It seemed that putting a nude into any painting would be perceived as somehow erotic, and this was another connotation Oliveira felt distracted from the deeper resonance he wished to insinuate.

The invented sites created by the artist during the 1970's and 80's continued to draw viewers into uncertain realms. While many of these

images suggest a kind of archaeology, they appear to be made by living cultures whose inhabitants appear in separate paintings. The sites are redolent with hints of rite and ritual, and also with the suggestion of societies who built and created while remaining in concert with nature. The images thrive on suggestions of human presence, while refusing to admit details of time or place. The sites are another example of Oliveira's tendency to avoid specificity, and let the human, the abstract, and the irrational flood into perceptual empty spaces.

Often, the absences in Oliveira's art provide enthralling moments. In his mid-career works, he willed the figure to disappear, and found himself, and his viewers, entering into spiritual territory. The presence of fetishes, steles and totems stood for human presence when the figure itself was absent. The writings of anthropologist James Hillman offer some ideas and explanations that seem to parallel Oliveira's ideas about subjects and presences.

By our use of them to keep ourselves alive, other persons begin to assume the place of fetishes and totems, becoming keepers of our lives. Through this worship of the personal, personal relationships have become the place where the divine is to be found, so the new theology asserts. Human persons are the contemporary shrines and statues where personifying is lodged.

Oliveira's approach to the human figure, from the beginning of his career onwards, has been one of personification. His imaginative approach has constantly suggested that art needs to take the figure out of the mundane context of the present into the world of the eternal: the spirit world. Whether his figures are faceless and featureless, as in *Red Couple* or loaded with anthropological suggestion, as in *Shaman 5* they connect us to a world vibrant with human magic.

Always a sensual artist, Oliveira's world demolishes literal boundaries and categories, and suggests that sensation transcends meaning. His images begin with sensual perceptions which he has taken towards the eternal by demolishing their literal meanings. It is a world of immortals, always present and available to anyone with imagination.

According to Joseph Campbell, the difference between a Shaman and a Priest is that a Shaman is not connected to institutionalized reli-

gion. Oliveira, a non-practicing Catholic, uses images like *Shaman 5* to reclaim faith and magic from religion and restore it to individuals in the form of visionary consciousness.

The artist's recent *Red Couple* suggests co-existence in a world where figures are indeed personified as shrines or objects. It is as if the erasure of their human particulars is accomplished with a painterly process parallels a stripping away of differences: culture, gender and other categories are released and a new kind of relationship can be contemplated.

Human figures are not the only ones loaded with personifying magic in Oliveira's art. Animal forms co-exist in the same equilibrium, and many of them—including dogs, baboons and hawks—seem to be incarnations of animal deities found in earlier societies. His figures and animals all belong to a Pre-Columbian world of coexistence. It is a kind of Mayan or Egyptian world where the biblical idea of Eden and its opposites has not been introduced.

Oliveira's engagement with the eternal has led him into conversations with many artists, writers and works of art. He has created series that came from artistic dialogues with Goya and Rembrandt, and has built themes on poems by Poe and Hopkins. In each of these cases he has treated works by past artists as living documents, seeing art history not as a series of periods and styles, but as a continuous dialogue. In that sense, it may be misleading to call Oliveira a Modernist, as he envisions himself as an artist in the same way the carver of an Egyptian statue of the Pharaoh 4,000 years ago was an artist.

Oliveira's *Windhover* paintings, inspired by a Gerard Manley Hopkins Poem, are abstracted from images of wings, rainbows and skies. Compared to Postmodern art—which tends to be rooted in theory—the *Windhover* images favor intuition and sensory input. In a remarkable way, Oliveira has reached backwards in art history. The *Windhovers* have as much in common with Catholic Baroque art as they do with modernism. Like Baroque art, using the sky as a metaphor and inspiring awe and spiritual musings. Like Abstract Expressionism, including the artist's personal energies and interest in improvisation.

After more than five decades of leaving behind the "real" world and

creating a new, better one in his paintings, Oliveira has found that forgetting details can be liberating. Dismissive of art world fashions, and of intellectual currents, he has had the luxury of losing himself in his work, and forgetting the problems of the world. The figures in his art have been simply a starting place for the artist's lifelong process of moving towards abstraction.

In this process he has found himself.

I'm not chasing the art world and what it's supposed to be, I'm trying to find what I'm supposed to be. That's what I have been doing for 50 years.
 - Nathan Oliveira

Originally written for EBSQ Self-Representing Artists Magazine in 2003

MASKS AND OTHER SPECTRAL PRESENCES: PRINTS BY NATHAN OLIVEIRA, 1952 – 1972

Nathan Olivera's mask collection, 2009

"Nothing has changed, but everything has changed."

That is what I am thinking as I sit down in Nathan Oliveira's living room on a sunny Friday in November, 2007. Nathan has lived in this home on the outskirts of Stanford University for more than forty years, and I bring with me the warm memories of visiting him here thirty years ago when I was an art student. Time vanishes for me as I

glance into the long dining room filled with tribal masks and totems. Wasn't it just yesterday that I was twenty years old, sitting at the long, rough-hewn dining table, having coffee with Nate and his wife Mona?

The house is still filled with Mona's presence almost a year after her death at age 77 from cancer. An exceptionally generous person, she shared her home and her husband with scores of students, artists, collectors and friends, anchoring a very vital household for a very long time. "She made this" Nathan tells me, taking in the serenity and beauty of the home and its precious objects as he speaks. The truth is that he and Mona made it together, and Oliveira's accomplishments as an artist are deeply intertwined with his roles as a husband, father and teacher.

Oliveira's son Joe has stepped in to keep the home and studio running, and when Nathan invites me into the long studio adjoining the south side of his home I can see that Joe is keeping his father's art supplies well stocked. There is a runway of clean paper under a large *Windhover* painting in progress on the south wall. Opposite the painting are two comfortable chairs into which my former professor and I settle, joined by a guardian Rottweiler named Rocco, to take it all in.

Now, after devoting himself to Mona while she endured major surgery and a painful decline, Oliveira has been spending more time in the studio, slowly getting back to the work of being an artist. With the sensation of loss so present, it makes sense that his most recent works, a series of masks sculpted in wax and bronze, have a funereal quality. Looking over one of these works in Nathan's studio, I also can't help thinking that throughout Oliveira's long career as a painter, printmaker and sculptor, masks and mask-like faces have been constantly appearing in, and haunting his work.

When he demonstrated the making of monotypes to my printmaking class in 1977, I remember Nathan stating that one of his artistic goals was to make things "come alive." Looking back over his immense output as a printmaker, it is clear that from the very beginning he has had an uncanny ability not only to suggest life in his images, but to go beyond that and depict an enveloping consciousness of life. Whether working in etching, lithography or monotype, Oliveira

has found striking ways to depict human presence, and has done so in a way that defies the particularities of time, history, style and resemblance.

Oliveira's tendency to create mask-like faces is a kind of paradox, since his artistic intention is to reveal, not to cover up. In essence, Oliveira has a long-standing tendency to work like a portrait artist, but in reverse. By starting with a model, or even better a memory, he strips away the particulars that help us distinguish an individual. This gets him closer to an inner truth, rarely a psychological one, more often a spiritual one. Oliveira seems to agree with Picasso, who famously covered two women's faces with African masks in his 1906 *Demoiselles d'Avignon* that the tradition of representational portraiture in Western art had somehow killed off something quite vital to the heart of art.

Studying with the German Expressionist master Max Beckmann in 1950 must have helped give Oliveira confidence in his quest to paint inner revelations. In the works of Beckmann, a moralist, carnival masks often function to remind us that his characters have something to hide.

In Oliveira's work, the idea of a mask is much trickier. When the eyes of his figures turn dark and empty, the mask-like face that remains is something like a trace or a memory. It is as if someone we are trying to remember—or even several people— flicker in our brains and briefly haunt us. One of Oliveira's talents is his ability to take something fleetingly beautiful and give it staying power.

In the lithographs he executed in the early 1950s, including an early portrait of his wife printed in 1952, Oliveira used resemblance as only a starting point. The finished print depicts the artist's wife with a kind of Romanesque solemnity, the contours of her features emerging as if carved from a network of spatters and striations. In transforming his wife into a kind of archetypal figure, the artist's interest in the universal, as well as his disinterest in the particulars of resemblance, are already apparent. Although early, this work bears Oliveira's distinctive stamp.

As Jo Ann Moser, referring to a similar early lithograph, points out in her 2002 essay:

> "*The dramatic, large, white, mask-like face emerging from a dark background became a favorite motif in his (Oliveira's) later lithographs.*"

Emily, a lithograph from a decade later, contains a free-floating mask that seems to have been removed from a more complete figure. Ambiguous in terms of style and setting, *Emily* evokes archaeology: maybe this face was pried off the marble figure of an enthroned goddess thousands of years ago?

The idea of a floating mask, and all of the spiritual connotations it can suggest, comes to fruition in the amazing series of lithographs, completed in 1963, that Oliveira dedicated to the 19th century French artist Eugene Carrière. Although the first print in this series, "Homage to Carrière," uses a self-portrait as a starting point, resemblance once again is swept away during the artist's attempt to move his work towards a spiritual consciousness. As Moser describes it:

> *The face is generalized and flattened, like a death mask that represents a spirit rather than a specific person.*"

The specter of Carrière goes through an astonishing transformation in the second state of the print, executed on a zinc plate. The mask turns black—it floats like a screen of ash—and the dark voids of the eyes present in the first print are reversed to become empty and white. This state, which Oliveira titled *Black Christ,* puts the viewer in a remarkable situation, seemingly standing behind the dark mask of Christ and seeing through it towards a blinding vision of light.

The *Black Christ* and *Black Christ II* set on a deep maroon field take us not only into the world of the eternal, but suggest that all the presences involved—Carrière, Oliveira, Christ and the viewer—are deeply and permanently co-mingled. In four states of one image, Oliveira has demolished any literal interpretations we may have had, and used the visual to take us into the metaphysical.

While the impact of Oliveira's prints is often established by process and transformation, as in the *Carrière* series, his single works can also possess startling graphic energy. The *Spanish Woman* of 1964 presents a dark woman whose features are suggested by a hovering nest

of black lines. Yes, the woman is there, but her presence is so insistently graphic that we have to think of the artist and the nervous tension he must have concentrated to conjure her up. She is a beauty that Giacometti and Picasso would have fought over, had they imagined her.

The chiaroscuro *Head of a Young Man* from 1966 has been seemingly scoured white from a black background. The bridge of his nose and his eye socket are banded by a dark oval that could be called a mask if just a hint of the man's eyelid were not etched out of darkness. Little is revealed about this male presence except in abstract terms, but he tempts the imagination. The dark tension of the image recalls Spanish Baroque painting, but we don't know if he is a saint, a criminal, or even the artist's own self-recollection.

In 1970, in his first show at the Galerie Smith-Andersen, Oliveira showed a series of glass-plate monotypes: floating masks printed on delicate Japanese rice paper. The facial contours of these phantasms emerge from bands of primary colors that float surrealistically over vestigial horizons. Almost magically, fragments of recognizable features appear, coaxed out of pigment by the artist's fingertips. Rarely has an artist created images of consciousness out of such fragile and direct methods.

The shamanic men and women who populate Oliveira's lithographs of the early 1970's demonstrate that the artist was finally ready to infuse his art with greater particularity, but not too much. Interestingly, the most prominent forms appear to be willfully invented, suggesting again that Oliveira was relying more on a spontaneous way of creating forms than on any renewed interest in observation. In *Woman, State III* of 1971, a graceful crook-shaped line hangs like a shroud over the reticent features of a dark woman. Her world, the print seems to say, is beautiful but a bit beyond our understanding. She is part of something, but it may not be of this world.

After visiting in the studio for an hour, Nathan took me to his office, thickly lined with art books and catalogs. We glanced at a slide of an Etruscan funeral mask he had chosen for a recent artist talk, and then Googled up some images of King Tut's newly restored mummy and black, gnarled feet. There was more to talk about, but I could see

that he was ready to get back to painting. Nathan is unique in so many ways—for starters, he is the only Knight of Portugal I know—but what really strikes me most about him is his utter consistency and generosity of his spirit.

When I came to Stanford in 1975 I heard the whispers about the "country club" school I was attending and was ready to find snobbery and elitism surrounding me. Instead, I wandered into Nathan Oliveira's printmaking class and entered the world of an artist who avoids hierarchies, doctrines and differences. By devoting his life and art to the idea that human beings have much more in common—over time, and across all invented boundaries—than most of us would imagine possible, he has created a striking world of human presences. They want to tell us something about ourselves, and about the human connection we share. His art seems to say: "Look closely and differences fall away."

Driving away from his home I glance over at the Stanford hills where he and Mona loved to walk. In my rear view mirror the outline of a hawk briefly rises and then careens out of view. Nathan Oliveira, I think to myself, has spent his lifetime making something quite beautiful. It is a beauty that appears unexpectedly, and then hovers in our imaginations.

Written as a catalog essay for Smith-Andersen Galerie, 2008

"BASEL MURAL I" BY SAM FRANCIS: AN ARTIST AT THE HEIGHT OF HIS POWERS

Sam Francis by Mimi Jacobs

The single most beautiful and moving abstract expressionist painting I have ever seen is *Basel Mural I* by Sam Francis. I know, that is quite a strong statement, but I'll stand by it until I come across a painting I like better. I doubt that will happen anytime soon.

Painted between 1956 and 1958, *Basel Mural I* originally hung in a stairwell of the Kunsthalle Basel along with two companion pieces, *Basel Murals II and III*. The group of paintings was broken up and disbursed in 1964.

In 1967, after some conservation work, Francis donated *Basel Mural I* to the Pasadena Art Museum, which later became the Norton Simon

Museum. It now shares a room at the Simon with two vertical fragments of *Basel Mural III*—which was re-stretched into 4 tall, separate panels after it was damaged during shipping—while *Basel Mural II*, which is intact, is 5,500 miles away in the collection of Amsterdam's Stedelijk Museum. In other words, *Basel Mural I* is a survivor: one panel of a triptych that will never again be entirely whole.

Basel Mural I is a painting that never fails to touch me at a very deep level. Majestic in scale, measuring just under 13 feet tall and nearly 20 feet wide, its vivid blues, blazing oranges and golden yellows burn brightly in a white field that to me represents what art historian Kirk Varnedoe called "the white light of mysticism."

Gorgeous, seemingly alive, and resolutely abstract, *Basel Mural I*, and the two other murals that once accompanied it, have their aesthetic roots in the vast, horizonless Monet *Nymphéas* installed on the lower floor of the Musée de l'Orangerie in Paris. It also draws inspiration from Japanese art, one of Francis's lifelong preoccupations. Painted in oil, with some areas that have the transparency of watercolor, *Basel Mural I* is a painting that goes beyond its visual sources and beyond the tangible into something else entirely.

Trying to put into words—in aesthetic and art historical terms—just where the mural came from, where it went, and how it did so strikes me as a potentially frustrating and limited exercise. Simply calling the painting and the artist who made it "mystic" might be the best approach. Francis would have agreed. "The making of a painting has no past that can be traced," he once told an interviewer. "You can't trace it through the art history, through the forms and analysis and all that crap." Francis may have been in a bad mood when he said that, but I'll keep his words in mind and write as well as I can despite the warning.

If you haven't seen the *Basel Mural*, you very likely don't know what Sam Francis was capable of at the height of his powers. When I was an art student in the late 1970s and early 1980s I remember seeing Sam Francis prints almost everywhere. Yes, works by Francis could be found in major American, European and Japanese art museums, and at the prestigious Andre Emmerich Gallery on 72nd Street in New York, but they could also be found in the tourist trap galleries on Fisherman's

Wharf in San Francisco alongside works by over-exposed artists like Salvador Dali, Peter Max and Leroy Neiman.

During a visit I made to Francis's Santa Monica studio with dealer Riko Mizuno in 1983, I was more impressed by the productive chaos of the place than I was by any of the paintings I saw. That experience reinforced the idea that Sam Francis knew how to make a lot of art and turn it into a lot of money, but I didn't yet understand the man's greatness.

The *Basel Mural* has served to re-educate me: Sam Francis was extraordinary.

"When Sam was good," says one of his lifetime friends, art dealer Paula Kirkeby, "he was very, very good." Critic Peter Plagens, writing in *ArtForum* in 1999, commented, "I've always thought the greatest Francises are easily better than the best Diebenkorns." "I've worked with lots of artists," master printer Jacob Samuel told the LA Times in 1995, "but nobody had what he (Francis) had." In a 2008 film by Jeffrey Perkins, *The Painter Sam Francis*, art collector and museum director Pontus Hulten states that at one point in the '50s Francis was the most expensive living artist in the world, an amazing feat considering that Picasso was still alive at the time.

Basel Mural I strikes me as having a very full emotional range; from exultation to pain. Pain was certainly a constant in Francis's adult life. In fact, his career as an artist began with pain. While piloting an Air Force trainer over the Arizona desert in 1943 Francis ran out of gas and was badly injured in the crash that followed. He spent more than a year in the hospital recovering from spinal injuries and experienced lifelong problems related to spinal tuberculosis. Francis was devastated that he never earned his Air Force wings and that he was never able to become a reconnaissance pilot as he had planned.

Learning to paint, initially with watercolors, was a way for Francis to cope with disappointment, intense boredom, injury and illness. "He painted to stay alive," says Debra Burchett-Lere, the director of the Sam Francis Foundation.

Antoine de Saint-Exupery, the French writer and aviator, wrote that "One of the miracles of the airplane is that it plunges a man directly into the heart of a mystery." Saint-Exupery, who wrote that after he,

like Francis, walked away from an airplane crash, he understood how flight transformed the modern psyche. Francis's son Shingo says the freedom his father felt while painting related to the freedom and exhilaration he had felt while flying. I can't help thinking of Francis rising phoenix-like in the decade after his accident, transformed from a medical student studying the rational sciences into an abstract artist pursuing the unknowable.

Peter Plagens has written metaphorically about Francis's paintings of the late '50s as pilot's-eye views over an ocean, characterizing them as "mural-sized canvases whose oceans of glaring white are interrupted by continents, islands, peninsulas, and isthmuses of intense blue, red, and yellow..." The website of the Norton Simon characterizes the fragments of *Basel Mural III* as containing "References to the sea and sun through radiant blues, oranges and yellows..." Francis himself wrote in his journal that the working on the Basel murals was like "doing huge sails dipped in color... They are like huge sails and I must be a strong wind for them."

Although it is tempting to see the horizonless *Basel Mural I* that way—as related to sails, islands and oceans—I also feel strongly that it has something to do with experience of flight. "I have destroyed the ring of the horizon and got out of the circle of objects," exhorted the Russian abstractionist Kasmir Malevich. "Comrade aviators, sail on into the depths." That is the call I think Francis was heeding, the lure of the depths of the unfathomable and the purely abstract.

The idea of a floating world, inspired by Monet's water lilies, gave Francis a visual threshold to cross. Aviation gave Francis the yin and yang of flight as the portal to mystery and also taught him about gravity, the enemy of flight. There is nothing like a crash in the desert to teach a young man the mortal power of gravity, or at least it seems that way to me. When I look at the drips and rivulets of *Basel Mural I*, I feel the action of gravity pulling on its hovering brushstrokes.

Francis's use of bold, complimentary colors gives his *Basel Mural I* its dramatic counterbalance and its considerable emotional tension. It should be noted that the mural's complimentary colors scheme is reminiscent of the way Vincent Van Gogh punctuated his blue night skies with yellow and orange lights, stars and moons.

The philosopher and literary theorist Jean-Francois Lyotard, in his book *Sam Francis, Lesson of Darkness*, states, "Color evokes conflicting feelings in the artist: ... color says to me: 'Come, I am your consolation, I cure your melancholy.'" Shingo Francis, an artist himself, remembers dropping by his father's studio after school and working on his own paintings. When Sam would comment on his son's canvases, color was the central aspect of many of his critiques. Looking over his son's painting he would discuss "This yellow, this blue..." and so on.

As an adult, Shingo Francis has visited *Basel Mural I* and the two fragments of *Basel Mural III* at the Norton Simon, where they have made a strong impression. "There is a quality there that is very light and spacious," he says. Recalling the mood that the mural evoked as he approached it, Shingo felt that its "melancholic blues" became "more and more intense: as you get into the room they are singing. The drips and blues and some of the red have the quality of sadness."

Shingo also recalls seeing the two verticals from *Basel Mural III* in the storage racks at his father's studio. "They were in his racks for years: he used to say it was really too bad that they were damaged in the shipment from New York in the hull of a ship." At the Norton Simon, two vertical sections of *Basel Mural III*, donated to the Simon by the Sam Francis Foundation in 2009, are on display to the right of *Basel Mural I*. "The strips in themselves are really beautiful," says Shingo Francis, but he also acknowledges that his father saw *Basel Mural III* as "something lost forever that will never come back."

Francis gave two other salvaged verticals cut from *Basel Mural III* to his friend, philanthropist Betty Freeman, who paid for the conservation of the Basel works. Those paintings remained in Freeman's estate following her death in 2009.

When Sam Francis died in 1994, he left behind a huge trove of art and a trail of personal tangles to sort out.

"Sam was dark and light and loved complete chaos," says Paula Kirkeby.

Originally published in The Huffington Post, July 27, 2011

RICHARD DIEBENKORN: THE BERKELEY YEARS (1953-66)

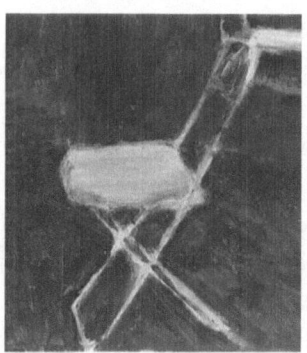

Detail of a Diebenkorn painting

It's too bad that the exhibition *Richard Diebenkorn: The Berkeley Years* didn't travel to New York after it closed its run at San Francisco's De Young Museum. It went on to be seen at one other California venue—The Palm Springs Museum—but had it traveled to Manhattan, *The Berkeley Years* might have shaken things up considerably. The accepted history of American painting in the 1950s and 1960s would have needed to be re-written with Richard Diebenkorn and California postwar art occupying far more prominent positions.

During the same period when East Coast critics were lavishing

praise on three successive movements—Abstract Expressionism, Pop and Minimalism—native Californian Richard Diebenkorn stayed on the West Coast hybridizing and synthesizing. He grappled with Abstract Expressionism on his own terms, barely noticed Pop and then infused his *Ocean Park* paintings with a respectful injection of Minimalism. The works Diebenkorn made during his years in Berkeley reflect his artistic dialogues with Edward Hopper, Northern Expressionism, the work of Bay Area colleagues and the French lineage represented by Cezanne, Matisse and Bonnard. Richard Diebenkorn, a patient and discerning man, was a syncretist of genius.

Diebenkorn isn't a good candidate for a full biography as his bourgeois and stable personal life leaves little to gossip about, but his mid-career paintings stand ready to reveal a great deal about his fascinating inner life. *The Berkeley Years* contains both masterpieces and quirky unresolved works: viewed in concert they offer revelations into the artist's thought processes and predilections. This exhibition is especially precious in the sense that it displays tensions and doubts that were later increasingly veiled behind a screen of privacy in the emotionally opaque *Ocean Park* series.

The show begins with Diebenkorn's abstract *Berkeley Series* paintings which responded mainly to the Abstract Expressionist models provided by the pioneering artists Clyfford Still and Willem de Kooning. Looking over these works with Mitchell Johnson—a painter friend who viewed *The Berkeley Years* with me in San Francisco—it became clear that Diebenkorn had a very different temperament from the avant-garde pioneers he was influenced by. Mitchell observed that "Diebenkorn is the introverted foil to the attack you see in Clyfford Still's egomaniacal work."

Even when Diebenkorn was flinging paint or applying it with some degree of frenzy there was always a sense of schematic restraint in his compositions. Diebenkorn's works lack the elevated confidence of fanaticism and the finesse of charlatanism. His relatively even-tempered *Berkeley* canvases are moderated by a sense of intellectual and emotional reticence that is lacking in De Kooning's Oedipal tantrums and Still's brutal crags. To put it another way, Diebenkorn appears to have had some principled doubts about action painting, but

he gave it a try and his work gained confidence and vitality from his engagement with it.

By 1955 Diebenkorn was experimenting with figuration, influenced by the contrarian return to the figure that his great friend David Park had made. "For someone who was intending to continue as an abstract painter, I was clearly consorting with the wrong company," Diebenkorn later acknowledged. The representational paintings he made during the late 1950s and early 1960s show the influence of his Bay Area peers—especially David Park and Elmer Bischoff—and they remain Diebenkorn's most memorable and revealing works. In later years Diebenkorn spoke of the human figure having often been a "problem" that needed to be solved. Responding to the challenge of the figure eventually brought out some of Diebenkorn's most deft and elegant brushwork.

Making the figures "work" in their painted surroundings was always a positive problem and many of his solutions are brilliant and original. Sometimes Diebenkorn's formalist instincts overwhelmed his feelings about the figure, and the resulting paintings could be a bit chilly: during his lifetime Diebenkorn was often annoyed by what critics had to say about a perceived emotional distance between the artist and his human subjects. In truth, even some of his most beautiful figures emanate at least a hint of isolation. As Mitchell Johnson put it:

> *The really great figures are so accessible and compelling in their composition, but they are also tragic. You feel the shapes surrounding the figures harnessing them into the composition but also pressing on them like weights of realization. They have an existential quality that separates them more and more clearly as time goes by from Diebenkorn's contemporaries.*

Mitchell also felt strongly that Diebenkorn's sense of doubt was an essential quality:

> *I think this is the greatest message of his work: that on some level, the world doesn't deliver itself to you, it doesn't preexist. You make sense of it. You make your world.*

After Park's death in 1960, Diebenkorn seemed to find his own distinctive subject matter that began to include vacant interiors and views of urban landscapes. With the human figure absent, Diebenkorn became more improvisational. One of the joys of the de Young show was to scan the surface of paintings like *Interior with Doorway* of 1962 and to see how the painting fell into place when the artist's final edits —such as the dark fields of negative space around the folding chair— caused the composition to lock into place. I couldn't stop looking at the gorgeous hints of colors pulsing through the chair's legs: they are traces of something beautiful that will never be fully revealed.

Some of the paintings in *The Berkeley Years* displayed the mixed results that occurred as Diebenkorn felt free to experiment with his subject matter. One was a very odd painting of a cluttered table with a Guston-like hand holding a cigarette reaching towards it. There was also a stunning picture of a studio utility sink that was a masterpiece of Zen brushwork. Diebenkorn's confident and masterful rendering of the zigzagging drainpipes under the sink has more abstract vitality than most Franz Kline paintings.

After returning from a trip to Russia 1964 where he viewed the incomparable Matisse paintings at the Pushkin Museum and at the Hermitage, Diebenkorn indulged in a final artistic apprenticeship painting homages to Matisse, including *Recollections of a Visit to Leningrad*. Diebenkorn learned a great deal from this final deep exploration and was especially sensitive to the stylizations and abstract tendencies in Matisse's works. By 1966 Diebenkorn—who knew when not to linger—had absorbed what he needed to and was ready to move on.

As Mitchell and I were preparing to leave the exhibition we stood in the final room and looked through a wide doorway into the well-lit gift shop crammed with shrink-wrapped catalogs and Diebenkorniana. To the left of the doorway hung a lovely but fussy painting of the artist's wife: *Seated Figure with a Hat*. To the right was a brave but awkward figure of a standing female nude: *Nude on Blue Ground*. The two paintings seemed to say the same thing: Diebenkorn had taken the figure towards two dead ends. In a perfect world *The Berkeley Years*

would lead into last year's OCMA retrospective of the *Ocean Park* series and not the gift shop.

Picasso once said that "the secret to creativity is knowing how to hide your sources." In his final *Ocean Park* paintings Diebenkorn certainly did more to hide his sources: or it might be better to say that he absorbed and sublimated them. Behind the veils and scumbles of their surfaces are vestigial traces of the influences, problems and subjects that he grappled with during his years of living in Berkeley.

Like other successful painters Diebenkorn has inspired too many epigones: lesser Diebenkorns who have learned from his surfaces and subjects but not from his intellectual scrupulousness. I hope that serious painters who saw *The Berkeley Years* have realized that what they need to borrow from Diebenkorn is the studiousness and patience with which he chose and learned from his peers and predecessors. They also need to pay close attention to the fact that at a certain point he subsumed his sources and became Richard Diebenkorn: an utterly unique figure. "Be yourself," Oscar Wilde advised. "Everyone else is taken."

I honestly think that *Richard Diebenkorn: The Berkeley Years, 1953-1966* is the most engaging show about an artist's early development that I have ever seen. Diebenkorn was never part of the leading edge of American art but by thinking through a wide range of influences and ideas he ultimately out-distanced many of his showier peers. In an era when too many American artists began to believe the lofty praise that came their way, Richard Diebenkorn managed to stay humble and curious. He had just enough doubts about himself—and about his art—to be truly great.

Originally published in The Huffington Post, September 24, 2013

THE OTHER END OF THE STICK: RICHARD DIEBENKORN'S OCEAN PARK SERIES

Richard Diebenkorn by Mimi Jacobs, 1977

When Richard Diebenkorn, who had been painting representationally for more than a decade, decided to switch back to abstraction in 1967, the changeover represented a dramatic reversal in his artistic direction. The difference between figuration and abstraction, the way he saw it, was enormous; "...it's from one end of the stick, way over here," Diebenkorn told Susan Larsen, "to way over there, as far as I can go." The series of works that would result from this about-face, the *Ocean*

Park series would occupy Diebenkorn for more than two decades, and cement his place in art history. Writing in *TIME* magazine in 1977, critic Robert Hughes declared the *Ocean Parks* to be "...among the most beautiful declamations in the language of the brush to have been uttered anywhere in the last twenty years."

When Hughes wrote that tribute, Diebenkorn was only halfway finished with the series, which would ultimately consist of some 145 paintings—from 100-inch-high canvases to 6-inch-square cigar box lids—as well as 500 works on paper, and numerous monotypes and limited edition prints. The current OCMA exhibition, co-organized by the Orange County Museum of Art and the Museum of Fort Worth, and curated by OCMA curator Sarah Bancroft, is the first exhibition to focus solely on the *Ocean Park* series in all its variety and richness.

Choosing abstraction—the far end of the stick—meant abandoning the human figure, which Diebenkorn had employed, in aesthetic terms, as a "concentration of psychology" and also a "source of opposition." A man of restless, persistent intelligence, Diebenkorn liked William Butler Yeats' notion that poetry comes out of "the quarrel with ourselves." The human figure, most often female, set in and against painted environments, had been an element he had tussled with beautifully. "The more obstacles, obstructions, problems—if they don't overwhelm—the better," is how he once explained it.

Diebenkorn's career was marked by a series of willful shifts. He had made non-objective paintings while a staff member at the California School of Fine Arts after World War II, but in 1955 he followed the lead of his friend and colleague David Park by moving back towards then-unfashionable representation. "His development from non-objective to figurative painting has seemed sufficiently contrary to the supposed main direction of Modern art to cause surprise," wrote art historian Lorenz Eitner in 1965.

Yet despite his seemingly independent cast of mind, Diebenkorn was always sensitive to what was said about his work. He found it irritating when a show of his representational paintings in New York was criticized as demonstrating that he was actually an "abstract painter" whose figures were "pawns" in an intellectual chess game. According to

his friend Nathan Oliveira, Diebenkorn also chafed at the public reaction to a show of his figure drawings held at Stanford University in 1964, that he had created during a year of residency. In the artist's own mind, the numerous drawings of female nudes were informal studies, so he was annoyed when the poses of his figures were subjected to Freudian analysis.

After his appointment to an art professorship at UCLA, Diebenkorn moved into a studio at the corner of Ashland and Main Street in what is now downtown Santa Monica and made four last representational canvases. "Then," he later recalled, "I abandoned the figure altogether." Still, because of the artist's previous engagement with figures, landscapes and still lives, the *Ocean Park* paintings often seem anchored by hints of recognizable forms and infused with the atmosphere of specific places. As late as 1969, Diebenkorn made a gouache, charcoal and ink painting on paper—*Untitled (View from Studio, Ocean Park)*—that showed the palm tree and rooftops outside his studio, framed semi-abstractly by sensuous scumbled planes.

It is a tempting game to look at a painting like *Ocean Park #43*, from 1971, and actually locate bits and pieces of Santa Monica's Ocean Park district, where Diebenkorn had established his studio. Taken literally, the upper left side of the canvas might be seen to include a trapezoid of moist morning air set behind a roofline, which in turn hovers over an ochre window. As pleasing as it may be to try and "see" things or locate specific environments in the *Ocean Park* paintings, doing so goes against Diebenkorn's wishes: "I never tried to work in terms of this coastal light, ambiance, and yet people assume I do. There have been reviews that refer to rather specific things on the beach—hotdog stand or something like that—and I'm just making paintings, and this environment has produced such and such a look and feel."

"Diebenkorn was certainly affected by his environment, the light and colors and atmosphere," writes curator Sarah Bancroft in the catalogue for the OCMA show, "but the *Ocean Park* works were never abstract landscapes of his surroundings; they were a far more personal synthesis of his own decisions, attitudes and process within a particular microcosm to which he was sensitive."

Over its long span, the *Ocean Park* series required Diebenkorn to sustain his sense of invention and discovery within a somewhat uniform framework. When the imagery became too consistent, Diebenkorn would get testy with himself. In 1975 he made a series of monotypes during a two-day visit to Stanford University. One of them, dated 4/12/1975, carries the artist's note to himself, brushed in firm capital letters at its lower edge: "TAKE A GOOD LOOK DICK--THIS IS THE BLOODY FORMULA."

The best *Ocean Park* works have a paradoxical, fleeting sense of beauty; Diebenkorn worked hard to make sure nothing was too carefully limned or solidified. "I'm not a hard-edge painter," he insisted. Then again, he chided Nathan Oliveira, known for his flowing sense of line; "Have you discovered the straight edge yet Nate?" Using straight lines, added with a slim brush or vine charcoal, Diebenkorn cantilevered, braced and trussed atmospheric fields of paint and pentimento. As a kind of counterpoint, he would let the occasional rough edge or drip spill over his firm geometry: a nod to the irregularity of nature. In *Ocean Park #60* from 1973, for instance, a smartly brushed blue diagonal line in the upper right of the canvas is decorated by rivulets of wash that cling to it like tiny stalactites.

At his best, Diebenkorn was a kind of carpenter who built painted structures that somehow enclosed and sustained something evanescent. "In their initial impact," wrote Susan Larsen, "the *Ocean Park* paintings give one a feeling of breathlessness, as if the painter had, with risk, bridged a chasm to take hold of some radiant vision." Like Cezanne, Diebenkorn worked to generate the small sensations of feeling that occur when sight and memory filter through the mind, then the brush, onto the canvas. He was smart enough to recognize and seize the moments of beauty as they appeared, and disciplined enough to make sure he kept himself off balance during the search. He also had a fantastic feeling for local color and knew how to tune and modulate its opacity.

Characteristically, Diebenkorn was ambivalent towards the praise his work received from others. "I'm not comfortable being altogether comfortable, being accepted," he once confessed. *The Ocean Park works* —paintings, works on paper and monotypes—still resonate with his

principled discomfort. Before Richard Diebenkorn painted the *Ocean Park* series, who knew that an artist's willful reversals and private hesitations could add up so magnificently, or so elegantly.

Originally published in Art Ltd. Magazine, March 2012

SAYING "GOODBYE" TO DIEBENKORN

Diebenkorn paintings being crated at OCMA

In the spring of 1988 Danny Shain, a young artist working for Cooke's Crating, was dispatched to the Santa Monica studio of Richard Diebenkorn. His job was to help the renowned painter pack up the contents of his studio in preparation for a move to Healdsburg, California. Shain, who remembers being a bit starstruck, did what he could to express to the older artist how much he appreciated his work.

"Diebenkorn was very pleasant," Shain recalls, "but I could tell that he was not thrilled about people telling him how great he was." Because Shain knew enough about Diebenkorn's work to understand

that a move to another location work would undoubtedly influence the artist's direction, he also gently asked about the reason for the move. Diebenkorn replied that he had been in Santa Monica "as long as anybody should be."

As the packing job progressed, Diebenkorn generously offered Shain various items including an old stepladder. Diebenkorn was a bit puzzled when the young man asked if he could also take home some of the trays that he had used to mix oil paint. "They are just photo developing trays: you can get new ones." he told Shain. They are now treasured items: "...the poetic shadow of his work," Shain remarks, "a journal of sorts of the making of his Ocean Park paintings."

Looking back, Shain remembers thinking a sad thought during the job: "This may be the end of the Ocean Park Paintings." In fact, it was. In his Healdsburg studio Diebenkorn worked mostly on a smaller scale, and the change in location brought a change in imagery. The artist's productivity was also greatly reduced by health problems that plagued him prior to his death in March of 1993.

Naturally, when he heard about the exhibition "Richard Diebenkorn: The Ocean Park Series," which was on view at the Orange County Museum of Art between February 26th and May 27th, Shain made a point of visiting the show. "I went with my family," Shain says. "I loved it." He wasn't alone in his enthusiasm. Before it closed, more than 21,000 visitors came to view OCMA's presentation of more than 75 Ocean Park paintings, prints and drawings, the largest selection ever seen on view together.

During the run of the exhibition it became clear just how many people have an intense devotion to Diebenkorn's art. Diebenkorn himself has become a cult figure, and the chance to see his "Ocean Parks" in Newport Beach, an hour south of where they were painted, was a kind of pilgrimage.

Diebenkorn aficionados came from across the U.S. and from as far away as Great Britain. OCMA intern Sarah Waldorf reports that a couple who came from Georgia saw the exhibition three days in a row: "They would arrive at 11AM sharp and leave right before closing. Every day they spent the whole day in the exhibition." Pulitzer prize-winning art critic Sebastian Smee flew in from Boston and wrote that "To stand

before these austere but drenchingly beautiful canvases is as close as art gets to the feeling of taking refuge on a cold day under a warm shower."

A New York couple who had dropped by MOMA in New York were told that the Diebenkorn they had hoped to see was on loan to OCMA; they immediately booked a flight west. The visitors desk at OCMA reports having often called taxis for people who came directly from the airport and then went straight back after getting their fill of Diebenkorn. Many people made multiple visits; I personally saw the show three times. Derek Allison, a northern Californian who regularly comes south for business, dropped in four times.

Painter Mark Dutcher, who saw the show three times, found the "Ocean Park Series" profoundly moving and compelling. "It was like a master's class in studio painting; a slowed down and deliberate painterliness sustained over twenty years. It brought me to my knees and was such a great reminder of what it means to be an artist and that being in the studio is all that matters."

Curator Sarah Bancroft, the show's organizer, had the privilege of seeing the show daily: "It was a daily meditation that just kept giving," Bancroft reports. "I did my hardest looking the day before the show closed." Bancroft, who had worked hard at hanging and arranging Diebenkorn's works, had her own personal names for some of the spaces, one of which she dubbed "The Diebenkorn Chapel."

> *What I casually referred to as the Diebenkorn Chapel was the space listed in the gallery guide as Gallery Seven. I called it the "chapel" because the works (c.1979-1980) that I hung there were very sumptuous, subtle, pastel, and it had a very quiet, light-infused, lovely feel. Three of the four paintings in particular (OP #109, OP #116, OP #122) did not have high contrast, and they really just took off and sang together. That room was like the "apotheosis of Ocean Park;" like being in heaven or going to heaven with Ocean Park.*

The meditative feeling inspired by Diebenkorn's works was intense. "People are crazy about their Diebenkorn," reports Bancroft, "and prefer it in silence." The Diebenkorn fanatics who "shushed" Sarah Bancroft—twice—while she gave a private tour near the end of the

show, made that clear to her. Poet Peter Levitt, who contributed an essay to the exhibition catalog, used standing meditations in front of various paintings to facilitate a writing workshop. As Levitt reports, the results were powerful; even cathartic:

> *All I did with the docents who came to the workshop was offer ways for them not to think the paintings as they were in their presence. I gave them ways to see them not with their eyes, but with other portals through which vivid life is known when we turn aside from thinking/seeing and allow the bigness of what we are to engage what is right before us. The result was completely spontaneous and authentic writing, some of which took my breath away, or drove it more deeply in to where I could feel it, myself, alive. I wasn't the only one who felt this way listening - there were many signs that the writing was getting through, and not a few tears of joy, recognition and relief.*

The day before the exhibition closed, Sarah Bancroft came across a man named Chris who was practicing Ki Gong in an opportune corner. "He looked like he was trying to commit the room to memory; he said he was meditating on all the works in Gallery Three plus the sight lines from Galleries Two and Four." His placement, comments Bancroft, was "perfect."

As soon as the show ended—after extended hours had been declared to accommodate the final crowds—OCMA's handlers began the melancholy task of preparing the Ocean Park paintings for their trip to the Corcoran Gallery in Washington. Each painting was carefully packed in a custom crate, ready to be accompanied by courier to its next destination.

It may be decades before another major Diebenkorn show comes along, and there is always the chance that "Richard Diebenkorn: The Ocean Park Series" will be the largest show ever organized. Collectors and institutions cherish their Diebenkorns, and after the Corcoran viewing the Ocean Parks will all be returned to their permanent homes in museums and private collections. "Ocean Park #90," which was on view only at Newport, is already back in billionaire Eli Broad's bedroom.

Saying "goodbye" to Diebenkorn's paintings won't be easy for his

fans, but while they were at OCMA many, many people took the time to look them over carefully, and felt their pull. After viewing the exhibition five times in 24 hours Peter Levitt told his wife "I don't want to live anywhere where I'm not surrounded by these paintings." Many viewers were struck by how "right" it felt to see the works in Newport. "It was akin to seeing a Cezanne exhibition in the south of France," remarks Danny Shain. For Shain—and for the many people who love Diebenkorn's work—the connection was personal and deeply felt.

Originally published in the HuffingtonPost on June 5, 2012

WHEN ART LIKES YOU BACK

Digital Collage by Photofunia

I once asked the art collector Hunk Anderson: "What do you enjoy most about living with art?" Without hesitation, he offered this description: "When the house is quiet, and everyone else is sleeping I like to go out into the dining room, turn on the lights and talk to the paintings. The ones that I like the most always have something to say to me. It's as if they like me back."

At the time, I found his reply eccentric, but from where I stand now it makes more and more sense. Liking and appreciating works of art involves a give and take, and the idea of a private conversation in which a work of art responds by deepening its meanings and offering more profound pleasures is apt and beautiful. It is precisely this kind of conversation that wakes up our taste for art, which involves a kind of deep affinity or even passion.

In my dual career as an art educator and art writer, I have come to realize that I am surrounded by people and institutions that want to tell me what I should like in art and what I shouldn't like. Everything about taste in art seems to have been externalized, institutionalized and circumscribed. No wonder so many artists try so hard to dispel all the cultural authority and "disrupt" since challenging external standards and measures of taste is one path to authenticity.

Museums, galleries, books, magazines and blogs all represent some level of authority that seems to conspire to warp my authentic taste, whatever it actually is. Even when you have spent years looking at art, the matrix of official taste looms and casts shadows on your choices.

My students feel the same pressure to like the "right" things, and they generally look to me as some kind of authority figure that can tell them what they should like. Since I don't want them to become "excellent sheep"—I'm an educator, not an indoctrinator—I constantly remind them that I can't do that. Taste in art is personal, and although it takes work to develop and bloom, it is innate: not learned. Deciding what you like in art is as personal as choosing friends or lovers, and letting others tell you what you should like in art strikes me as rather like having someone else choose a spouse for you.

Art is a magnet that draws strong opinions from those who look at it, rank it, collect it, write about it, or sell it, especially art world types who have some kind of vested interest. For example, what you find personal may strike others as political. Given that situation, privacy seems especially inviting. The collector's metaphor—that the paintings could talk back to him in his own home—screens taste from cultural politics. If you later have to discuss, defend or justify your taste in public, your time alone with a work of art will prepare you.

The word connoisseur derives from the French verb connaître,

which means "to know intimately" (even sexually). Certainly, artists of past generations understood this, and they relied on the beauty of things—bodies, landscapes and objects—to delight viewers into staring unselfconsciously and lovingly. Fast-forward to now and you will find that postmodern art often deals with abstract ideas, concepts and socio-political concerns. As valid and intellectually stimulating as these things may be, the result is often over-thought art that intimidates or lectures.

Art that is overly insistent on its own intellectual and political virtues can't generate the kind of back-and-forth conversation that my collector friend relished. The images and ideas broadcast by a truly great work of art have to awaken the senses first: they have to seduce you and then the "conversation" really takes off from there. Art that appeals to the senses sends a message: "I like you and I want you to like me back." Art that makes an effort to "like" its viewers invites responsiveness and offers deep intuitive connections and sensual resonances.

In his book about spiritual enlightenment, *The Power of Now*, writer Eckhart Tolle has devastating things to say about what he perceives as our overly conscious, "mind-dominated" culture.

> *Because we live in such a mind-dominated culture, most modern art, architecture, music and literature are devoid of beauty, of inner essence, with very few exceptions. The reason is that the people who create these things cannot —even for a moment—free themselves from their mind. So they are never in touch with that place within where true creativity and beauty arise.*

That is a very harsh statement, but I think Tolle is on to something. Contemporary art has been overly thought about and overly theorized, to the point that too much art has forgotten to "like" its viewers. The "liking" has increasingly been seen as the sole responsibility of viewers as the art itself has become more challenging or banal.

I think that Andy Warhol was saying something along these lines when he stated that "Pop art is about liking things." It was his way of saying that in a modern, consumer culture we all needed to ask less of the art object. In other words, it was time to accept the fact that art

objects, like products, had been stripped of their subtlety and mystery for the sake of consumerist immediacy.

I see it differently. In a fast-moving, fast-looking media/consumerist society art can be an antidote that can wake us up to slowness—to passion— and nudges our innate taste into wakefulness. Great art transcends the particularities of time, place and culture: it can break through limits and cultural assumptions if you let it.

The next time you are around a work of art, shut out everyone and everything else and open yourself up to it. Talk to the work of art and see if it talks back. If it likes you and you like it, nothing else matters. When a work of art likes you—by offering you images that entice and delight you—don't worry about whether or not others will approve of your taste. Turn on the lights of your mind, let everyone else sleep, and see if the work of art likes you. If it does, there is every chance that you are going to like it back.

Originally published in The Huffington Post, August 16, 2015

CONTEMPORARY ART ™ IS A NOW A 'BRAND'

A partial view of Richard Serra's Band *on view at LACMA*

What's a brand? A singular idea or concept that you own inside the mind of the prospect.
 - Al Ries, chairman and co-founder, Ries & Ries Focusing Consultants

If you are a museum-going Californian, there is a good chance you have seen one of Richard Serra's massive rusted steel sculptures. Since 2006, when Serra's torqued ellipse *T.E.U.C.L.A* was installed at the Broad Art

Center at U.C.L.A., California's finest heavy crane operators have been busy lowering a new generation of his works into prominent locations across the state.

I recently walked around Serra's twenty-ton *Band* on the lower floor of LACMA's Broad Contemporary Art Museum, where it is literally impossible to miss. Just an hour away, Serra's 66-foot-tall, 360-ton *Connector*, installed in 2013, dominates the pedestrian plaza of Orange County's Performing Arts Center. In the Bay Area, visitors to the first floor of SFMOMA's spectacular, newly-opened 460,000 square foot building are being greeted by Serra's 2006 *Sequence*, which was previously on view at LACMA and Stanford University's Cantor Art Center. *Sequence*, which consists of two conjoined steel spirals that weigh over two hundred tons, requires a dozen flatbed trucks when being transported.

Serra's art has become an instantly recognizable brand. When you see massive rusting steel plates in a museum or plaza, the word "Serra" flashes in your mind. A Serra is about massive weight, materiality and scale that controls your experience. Being in or around one—or watching one being installed—is meant to inspire awe and at least a tinge of sublime fear. Every Serra installation is both a work of art and a marketing device that reminds us of the artist's market dominance.

Richard Serra is routinely referred to as one of the world's "greatest living sculptors," and the artist himself isn't shy about concurring. In 2013, when Vanity Fair magazine asked 100 art world notables to select "The Six Greatest Living Artists" Serra voted for himself. Darren Jones, a Scottish-born critic now living in the U.S., begs to differ. In a recent, widely-circulated blog—"The Fascism of Recent Art History: A Conspiracy of Hysterical Importance"—Jones calls Serra a "McDonalds of the art world" who never fails to "miss an opportunity to dictatorially stomp his Jurassic footprint across the globe on the grounds of any museum that will house one of his insufferable metal tantrums."

Honestly, Jones seems to be the one having the tantrum—an art critic tantrum—but by comparing Richard Serra to McDonalds he does touch on an interesting point: it's not entirely off base to compare a leading contemporary artist to a ubiquitous brand. One artist friend of mine uses a similar metaphor to poke fun at a broader phenomenon.

He notes that contemporary art museums across the U.S. tend to showcase the same "menu" of blue chip contemporary artists, so he calls these museums "Olive Gardens." Theodor Adorno once cautioned that the "commoditization of culture results in conformity," and the seeping presence of "branding" into the field of contemporary art feels consistent with his warning.

Serra's *Sequence*, I would argue, is a kind of logo in steel that "sells" the related art "products" on view at SFMOMA, which is now the largest institution of its kind in the world. As any good marketing student knows, effective branding can result in the sales of not just one product, but of other products associated with that brand. The broader field of Contemporary Art ™, with its values of progress, boundary pushing and cultural significance, draws more and more well-educated, well-funded individuals towards its commoditized magnetism.

Just a block away from SFMOMA, mega-dealer Larry Gagosian has just opened his 16th location. Has there ever been a more powerful art brand than Gagosian Gallery? Gagosian has played a crucial role in advancing Serra's career, and the presence of *Sequence* at SFMOMA must be one of the most validating and powerful "product placements" ever. Gagosian Gallery, it should be mentioned, is listed as one of SFMOMA's Corporate Donors, right after Ferrari of San Francisco. Contemporary Art ™, like Ferrari, is a luxury brand.

In San Francisco, where the 2015 median home value is $1,135,900, luxury brands are the ones that do well.

Originally published in The Huffington Post, May 29, 2016

IS HAVING AN 'EYE' FOR ART A THING OF THE PAST?

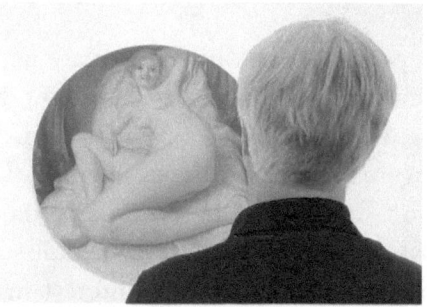

Viewing a John Currin's Reclining Nude *at Gagosian Gallery, Beverly Hills, 2015*

A few years ago I was standing in a Malibu furniture store looking at coffee tables when I heard another shopper whisper excitedly to a friend: "Hey, isn't that Bruce Willis? He looks just like he does in the movies, but maybe just a bit shorter."

I can confirm: it was Bruce Willis, and that was one hell of a nice Ferrari he was driving. He didn't look short to me, but I digress.

While viewing the recent John Currin exhibition last month at Gagosian Gallery in Beverly Hills, I found myself saying some rather

similar things to my friends Matthew Couper and Jo Russ, who were touring the show with me. Currin's paintings were already well known to me, but only in the form of photos in magazines and jpeg images seen on the net, and I assessed them just the way that the woman in Malibu had assessed Bruce Willis:

"They are a bit more painterly when seen in person," I told Matthew, "and the canvas is a bit rougher than I expected."

Of course, considered in the context of today's media-driven art market, these observations are inconsequential. Everything in the show was already sold—for $2 million plus each, or so I am told—and Currin's reputation as an art world star is well established. The feeling I had looking over Currin's work was that the paintings themselves were celebrities, glamorized by the fame of the artist who made them and their high market values. That isn't an original idea: I think it was Robert Hughes who more than 30 years ago said something along the lines that "Paintings are now celebrities and museums are their limousines."

Hughes was prescient in his observation and the recent phenomenon of museum selfies drives his point home very nicely. Being in the presence of a famous painting seems to be replacing—especially for younger art viewers—the experience of closely inspecting works of art. If you are interested in scrutinizing the surfaces of works of art slowly and scrupulously you are a connoisseur or possibly an artist with a kind of professional vested interest in a given painting's construction.

A case in point: when a number of my artist friends visited Kehinde Wiley's exhibition at the Brooklyn Museum recently, they had a lot to say on Facebook about how Wiley's paintings looked to the naked eye. There was quite a bit said about what Wiley's assistants in China had painted (the patterned backgrounds) and what he had painted himself (the faces) and also some comments about the fact that Wiley's technique was gradually becoming more confident.

I enjoyed hearing their first person observations, but also realized that they were having a similar experience to the one I had at the Currin show. Wiley has become famous because of the social messages of his artwork, especially his bold imagery of African-American men

presented in a context largely borrowed from the grand traditions of European portraiture. What I and my other "painting geek" friends observe about his work in person isn't going to affect his career trajectory at this point. Like Currin, Wiley has created a body of work that transmits its messages well in magazines and on the net, and that aspect of his work is very potent—and possibly essential—at this moment in time.

In a media society, the reputations of painters are made in magazines and on the web. Seeing surfaces in person is a luxury and an afterthought. A recent survey indicates that over 50 percent of contemporary art collectors have now purchased art on Instagram. There is clearly growing confidence among collectors that digital images can tell you enough about a work of art to spend big bucks. When the crate arrives, they can look over their purchases the way I looked over John Currin's paintings on the gallery wall and make a few discerning comments if they are so inclined.

If you have an "eye for art" and a keen interest in inspecting the surface of works of art, both out of curiosity and a quest for deeper meaning, your abilities are linked to an increasingly outdated notion of connoisseurship. Having an "ear" for art—which means that you pay attention to what people are saying about what is hot on the market—is the best tool for keeping up with the trends. Maybe all of this has something to do with why art critics, who have traditionally been relied upon to carefully scrutinize works of art and make critical pronouncements, seem increasingly impotent and irrelevant. When the editors of *Hyperallergic* suggested at the end of year that art critics might as well be replaced by Instagram, they made a very funny and rather relevant point.

When I can manage to pry myself away from my laptop and make the grueling drive into the city I always make time to see art in person. That said, I'm increasingly realizing that looking at art on the web is the only way I can really keep abreast of what is happening in my field. I'm still dedicated to the idea of connoisseurship, even in an age when visual ideas transmitted with immediacy are in the forefront. It's still great to visit museums and take things in slowly, inspecting the surfaces.

In L.A. there is also the chance I will see some celebrities, as they seem to frequent art museums. One of my students returned from a field trip recently and told me she saw Tom Hanks at the Huntington. She said he looked just like he does in the movies, but a bit older now.

Originally published in The Huffington Post, April 23, 2015

A BRIEF RANT ON THE EXHAUSTION OF THE AVANT-GARDE

Digital Collage by Photofunia

Try to explain to Monsieur Renoir that a woman's torso is not a mass of decomposing flesh with those purplish-green stains.
 - Critic Albert Wolff, writing about Renoir's Nude in the Sun

Hard to believe, isn't it, but Renoir's *Nude in the Sun* was once considered threatening: when first exhibited, it's Impressionist palette

violated long-standing academic rules about the use of color in shadows. These days you won't find a museum director anywhere in the world who wouldn't covet the tiny, sun-dappled nude, and the once offensive image is emblazoned on a coffee mug that can be purchased on eBay for $13.99 with free shipping. Now that its original aura of challenge and disruption has dissipated, a work of art that was once cutting-edge has now entered another category: it is a certified and fully commoditized masterpiece. *Nude in the Sun* should be considered "formerly avant-garde" as the cultural shock that it once evoked was exhausted years, even generations, ago.

To fully understand the original antipathy critics felt towards Renoir and other French modernists—Wolff, for example, felt Manet was an improviser whose work was marred by searching, hesitation and pain—it is important to recall that the sclerotic critic was defending the aesthetic ideals and traditions of the French Academy, an entrenched and formidable cultural institution.

Now, 140 years after Wolff derided it, *Nude in the Sun* resides in another kind of cultural institution, the Musée d'Orsay, and the tables are turned. Modern art and its children—Postmodern and Contemporary Art—are the "Academy" of our time, and the tradition of the avant-garde has been elevated and enshrined to the point that you might even say it has been embalmed. The values of the avant-garde, including individualism, experimentation and progress, are now sacrosanct, and the boards of Modern and Contemporary art museums in the United States are populated by the nation's wealthiest, most culturally elite citizens. They serve the same conservative role that titled aristocrats played in the European academies of the past. They are guardians of the dominant culture.

This creates real problems, as truly avant-garde works of art need the tension created by opposing cultural values and institutions to sustain their meanings and put them in relief. When too many people come to embrace avant-garde works and styles, their intended purposes and meanings wilt and die quickly. As a biologist will tell you, things grow best when subjected to the right stresses, and culture is the same way. Healthy values—including social, political and cultural values—need constant challenge and revision to remain fresh, and it

strikes me that the spirit of the avant-garde in art is exhausted and complacent: Its "progressive" values have become de rigueur. If you see the words "pushes the boundaries of..." in an art review, you have encountered a critical blandishment that has become a cliché, ready to be retired.

Modernism's ennoblement of progress—a value it absorbed from the Industrial Revolution—made new types of painting possible while demoting others. In the United States, Modernism's determined march forwards opened the door for Abstract Expressionism, America's most significant and genuinely avant-garde form of visual art. On the other hand, a continuing over-emphasis on the value of the "new" has strained and distorted many of painting's historical purposes and intentions. In too many instances the notion of "progress" has stripped meaningful content from painting only to replace it with novelty and gimmickry that poses as "new."

Realism, one of the related forms of painting that would have been acceptable to the members of European Academies, has been consistently relegated to the sidelines. As artist Eric Fischl noted in a 2009 interview, "There's always been realist painting. The avant-garde ignores 99 per cent of it."

Compared with Realism, the broader field of representational painting has done a bit better in finding its place in the avant-garde. I'll be bold and say that only 98 percent of it gets ignored. Generally speaking, the representational art that makes its way into the mid and upper ranks of the contemporary art field has to be credentialed as avant-garde in some fashion. "Outsider" status can work, as can a reliance on subject matter that is "deconstructed" in relation to social, sexual and political issues. Self-conscious strangeness, obsessiveness, and irony can "credential" representation and so can Warholian strategies involving mechanical and technological methods of image making. Conceptualism, which I think mixes with representation very lamely, can also get you in the front door of the avant-garde academy. A connection to wealth and/or celebrity is also a plus.

For representational painters whose work does fall into one of the categories above, there are pitfalls to be avoided. For example, painter Bo Bartlett believes that "To be earnest is the greatest taboo in

contemporary art." Any representations of conventional beauty that don't have a dose of nihilism mixed in are excluded from the avant-garde as "kitsch," but self-conscious super-kitsch is a hot ticket.

If I haven't transcribed the current rules and perimeters of acceptable avant-garde representation perfectly, I apologize: they aren't written down in a handbook anywhere, but they definitely exist. I also doubt that the French Academy had a manual forbidding purplish-green shadows on human skin, but Albert Wolff knew the rules and limits of his era's academy regardless. When a cultural system has ossified and become fragile, knowing the rules is especially important, and both artists and critics need to pay close attention. In New York right now, the matrix of unspoken rules has resulted in a vogue of abstract and semi-abstract paintings by young artists that play it safe by saying very little, but sell well. Critic Walter Robinson, who first noted the "reductive, straightforward, essentialist..." urges present in this new school of painting, gave it a grim, clever name that has stuck: Zombie Formalism.

Peter Schjeldahl, the art critic for the New Yorker, has been looking over this new genre of offhandedly abstract painting, and in his recent review of *The Forever Now: Contemporary Painting in an Atemporal World*, he observes that the young painters represented use "tactics" which "include emphases on gritty materiality and refusals of comforting representation." He also notes that the "joys" of the works on view come "freighted with rankling self-consciousness or, here and there, a nonchalance that verges on contempt." The "joy" he describes sounds very circumscribed indeed, especially for a show presented at MOMA, the original temple of America's avant-garde.

The "nonchalance" that Schjeldahl notes apparently exists in a void that critic Andrew Sullivan believes has been created in an art-world "bubble" inflated by "flipping" and the transformation of avant-garde works of art into bankable financial instruments. In a year-end commentary titled *Where Does 2014 Leave the Art World*, critic Goldstein derides Zombie Formalism complaining that: "The intellectual content that allowed previous developments in painting—gestural abstraction, process-driven minimalism, et cetera—to break new artistic ground is voided, leaving a colorful corpse so devoid of ideas

one could imagine it craving human brains." Is it just me, or does Sullivan's use of the phrase "colorful corpse" sound a bit like Wolff's complaints over Renoir's "mass of decomposing flesh with those purplish-green stains"?

The situations that both critics describe—even though their tone differs somewhat—strike me as symptomatic of avant-garde exhaustion: Zombie Formalism is an ironic, self-conscious artistic response to a situation in which academic rules have choked off the oxygen painting needs to breathe. And yes, it is also a tiny, over-commoditized, avant-garde zone supported by speculators. Andrew Goldstein thinks the movement is short of "intellectual content" and "ideas," but I see it a bit differently.

If the situation I have outlined sounds distressing—and in many ways it is—it is also a moment when change seems imminent. There are many fantastic artists out there making significant work, ready to burst onto the scene when change blossoms. There have never been more institutions dedicated to contemporary art or more money available to be spent on it, and that is a good thing. The problem is that the definition of avant-garde needs to be revised to encompass and include art and artists that are brave enough the reach backwards and forwards at the same time. The avant-garde of the future needs to feed itself with hybridization, consolidation and assimilation.

I think that painting has to look back over its shoulder to Realist and Academic painting before the Salon des Refusés; in fact, it can and should go all the way back to Lascaux if it needs to. I see the history of painting as a very long line with no beginning and no end. Culture has certainly created moments and movements in painting—most recently we have called them "isms"—and living in a media age, artists can have access to all of them, although not always on a first-hand basis. I like what the painter Jean Hélion said: "All the 'Isms' seem to me to be facets of a whole that should be painting."

There is a deep need for art that is authentic, engaged with the world and more about skill and knowledge than ego. Representation, which has been so restricted for the past decade, has vast untapped potential, and can be "progressive" in countless unexpected ways. As I think contemporary representation is coming on strong. I also think

that schools like the New York Academy, which equip students with a strong base of traditional skills, are equipping a generation of artists who will re-invigorate and re-define the avant-garde.

I would like to think that Zombie Formalism is the end-point of one kind of thinking about painting; as "isms" go, I predict it will be a blip. Peter Schjeldahl believes that "painting has lost symbolic force and function in a culture of promiscuous knowledge and glutting information," but I think he is wrong. As Renoir knew, when painting finds a way to resist rigid culturally imposed rules, it can persist, become relevant again and thrive.

Originally published in The Huffington Post, January 27, 2015

SO THESE THREE ARTISTS WALK INTO A JEFF KOONS SHOW: SOME THOUGHTS ON ART AND SKILL

Steven Assael and Mikel Glass view a Koons Gazing Ball painting

He who works with his hands is a laborer. He who works with his hands and his head is a craftsman. He who works with his hands and his head and his heart is an artist.
 - Louis Nizer

Reading the press release for *Gazing Ball*—which was comprised of meticulous copies of classic paintings bolted to aluminum shelves containing reflective blue glass balls—one might get the impression that Jeff Koons is a painter:

> "Gagosian Gallery is pleased to present a new series of paintings by Jeff Koons entitled *Gazing Ball*."

Yeah right, everyone knows that Koons doesn't paint, as this revealing quote in a 2012 New York Times magazine piece, "I Was Jeff Koon's Studio Serf" confirms:

"I'm basically the idea person," Jeff Koons once told an interviewer. "I'm not physically involved in the production. I don't have the necessary abilities, so I go to the top people."

I'll say this about Jeff Koons: you have to appreciate his honesty, and he does create employment for artists.

The "top people" who executed the paintings in *Gazing Ball* were paid $18 per hour: better than fast food workers but far less than, say, air-conditioner repair technicians. Steven Assael, one of New York's most respected and gifted representational painters, walked into the Gagosian show with two artist friends, knowing full well that many of the "Koons" paintings were in fact painted by artists he knows or has trained:

> *Many of the artists who worked on the paintings are very fine artists in their own right and to my knowledge are not given credit. Many are former students from SVA and the New York Academy whom I know...*

Having other artists make your work for you doesn't raise even an eyelash among top collectors these days. It's like saying that some top bankers should go to jail for their roles in the 2007-8 subprime mortgage crisis: it's old news and hardly anyone is interested, especially in New York. If you are hick enough to bring up any kind of objection to artists not executing their own paintings, you usually hear something

along the lines of "Ah, yes that has been going on for hundreds of years: didn't Peter Paul Rubens have an army of assistants?"

The answer is "Yes, he did" but with an important distinction. Rubens was fully capable of making his own paintings, and in fact was the "master" of his own studio in every respect. The popular contemporary painter Kehinde Wiley is also fully capable of executing his own canvases, but gets help from China, especially the backgrounds. Koons is truly an "Artist as CEO" who, if anything, seems to enjoy showing off the fact that skill is something he can afford. It's the current American corporate model isn't it? Fight your way to the top of the pyramid, outsource your production to capable, affordable underlings and harvest the profits.

Looking one more time at the photo of Steven Assael in front of a Rubens-derived *Gazing Ball* painting offers an opportunity to consider the full, weird cultural and economic bass-ackwardness of the "Artist as CEO" situation. Here is how one might frame the situation:

> Steven Assael, a subtle and profoundly skilled artist, stands in front of a methodically-executed copy of "The Tiger Hunt" by Peter Paul Rubens, a Baroque master who employed assistants to work on his paintings. Assael recognizes that the Rubens copy was executed by friends and students he has trained, but the credit goes to America's most commercially successful artist (Jeff Koons - estimated net worth $500 million) who admits that he cannot paint. Steven, by the way, can't get any closer than 2 feet away to assess the paintings as the gallery guards won't let him to close to the super-expensive work.

Maybe, just maybe, it's a good thing that skilled representation by friends and students of Steven Assael made its way into Gagosian Gallery. Maybe one of these days it will be their work (not copies of old masters) and they will be the ones whose names will be credited. Maybe the arc of the moral universe will finally bend their way...

Among the painters I know, skill is a hot topic. Everyone seems to intuitively know what it is—they know it when they see it—and the implications of having or not having skill are generating lively, fresh conversations and opinionated writing.

Last July when artist/educator Scott Hess—who visited the Gazing

Ball show with Steven Assael—posted his nerve-hitting blog "Is De-Skilling Killing Your Art Education" it quickly went viral, generating thirty thousand Facebook likes. Airing out his concerns over the current "academic prejudice against skill," Hess asserted that "only in the visual arts is training in the traditional skills of the profession systematically and often institutionally denigrated." Hess believes that the postwar dominance of Abstract Expressionism—and later Conceptualism and Post-Modernism—diminished the centrality of skill in art-making and generated this widespread negative bias.

More recently, in a dense and thoughtful blog about the "rise of Post Contemporary" art, writer Daniel Maidman writes that "skill" is the first of three "pillars" (the others are creativity and empathy) that form the foundation of a new movement in painting that sees itself as reconstructive. "The unskilled genius may have the vision," Maidman philosophizes, "but he or she is condemned to failing it, without first acquiring the eloquence of skill."

Reading Dan Maidman's words might make you anxious or angry, especially if you love modernist-derived painting and abstract painting (as I do). Isn't Modernism the period in which traditional skill—in the seemingly ossified guise of Academic art—was challenged and bypassed because it had become an obstacle to new forms of expression? Have we forgotten that "skill" was often used in the past to advance and justify art we might now find politically reprehensible or spiritually void?

Does Maidman's warning that being "unskilled' condemns an artist to failure imply that Jackson Pollock couldn't have been a "genius" because he didn't have the "eloquence of skill?" Does "skill" simply exist in the service of realism, and if so doesn't that make the idea of skill extremely constrictive? Those are some prickly questions with potentially divisive answers, aren't they? There are about a zillion more that flood into my mind as the implications of discussing skill begin to unpack themselves.

I think there is a need to step back first and think through a primary question that hasn't yet been effectively addressed:

What constitutes skill in painting?

In my view there is no single satisfactory answer and some breaking

down is needed. I would argue that there are two main types of skill (or skill sets) that are relevant in relation to contemporary painting.
- *Traditional Skill (aka Academic Skill)*
- *Idiosyncratic Skill*

In a moment, I'm going to try to lay these out—offering definitions that will be expanded as notes—but first I want to make a few overarching points.

Skill, in any form, takes time and practice to develop: it needs exercise. I like the assertion Malcolm Gladwell makes in his book *Outliers: The Story of Success* that it takes 10,000 hours of practice to achieve mastery in any field, and I think of skill and mastery as interrelated concepts. Skill resides in the brain but comes through the body: it has a kinesthetic dimension, and technical skill without a meaningful connection to mind and spirit is mere dexterity.

Finally, I believe the skills and skill sets I am identifying can overlap and that in contemporary painting they are frequently hybridized. In my rather accommodating view, skill isn't a static term that relates only to meanings that were fixed centuries ago.

Traditional Skill:

Traditional skill refers to the mastery of all the elements and methods needed to render form convincingly, accurately and beautifully. It is rooted in the Renaissance ideal of "disegno" which involves both the ability to draw as well as the intellectual capacity to invent and design subject matter and compositions.

Traditional rendering skills are tangible and teachable and include the mastery of scientific perspective, the depiction of form with line and shadow and facility with the tools and materials of drawing and painting: after the 16th century this predominantly refers to oil painting. The skills of imagination and invention are nearly impossible to teach—some of us have vast imaginative capacities and some of us are born dull—but the concept of disegno evolved partly to acknowledge and reward the level of imaginative drive associated with genius, which during the Renaissance was a relatively new idea.

The look and feel of traditionally skilled painting never stood still,

as it evolved and changed in relation to new materials—for example the introduction of new pigments—and various masters took the whole notion of skill into new territories over time. Traditional skills constituted a kind of marvelous subtle toolbox that a few exceptional artists used with transcendent skill. In the hands of hacks these same marvelous tools gave birth to mediocre and worse works.

The invention of photography in the mid-19th century mechanized enough of the magical processes of painting that skilled naturalism began to lose its hold on the public imagination. The resulting bias against realism in painting remains strong today.

Idiosyncratic Skill:

Idiosyncratic skill—a category of my own invention—refers to skills that are highly individual. They may or may not derive from traditional skill, but evolve in concert with an individual artist's personal development and in relation to his or her aesthetic goals and concerns. Even among the oeuvres of artists we think of as traditionally skilled, there are instances of idiosyncratic skill. Titian's heavily-brushed late works are one prime example.

Many modern artists had academic training in traditional skills that formed the foundations of their rebellious stylistic experiments. There is, for example, an exceptional knowledge of form underneath Picasso's distorted Cubist compositions, and a flair for disegno is clearly apparent in de Kooning's energetically abstracted figures. In my view, traditional skill was often hybridized in modern painting—it morphed into idiosyncratic skill—and the process continues to this day.

I see plenty of skill in modern and contemporary painting, but it is often far removed from the "traditional skill" that key schools and ateliers are attempting to revive. Skill in modern and contemporary painting is hard to objectify, and I'm sure that many would disagree with me and say that "Idiosyncratic Skill" is a valid category or concept. To them I would say this: I know it when I see it. It is there in the practice, dedication and inner-derived vision and execution of strong modern and contemporary painting. It is the ingredient that is sorely lacking in "zombified" works, and I will leave it to you and your eyeballs to pick out the works in which you find skill of any kind lacking.

Skill in art is no joke, and whether you like your skills traditional, idiosyncratic or both—and I like both—I say it is time to reward skill and let the model of artist as CEO fade. I say bring on the Post-Contemporary painting and bring on the idiosyncratically skilled painting, too: down with brand names and up with individual talent. The artists who currently work for Jeff Koons are being paid as "craftsmen" for doing meticulous copying. In the universe of a CEO artist, where skill is bought and idiosyncrasy is flattened and systematized, their artistic futures are being held hostage.

From my point of view artists like Steven Assael (and his friends and students) look better and better every day.

Originally published in The Huffington Post, December 26, 2015

HELL HAS FROZEN OVER: FIGURATIVE ART IS POISED TO BECOME THE 'NEXT BIG THING'

News item in the New York Times, October 2015

That's right: hell has frozen over, and pigs are flying too. After decades —some might say well over a century—of standing aside while Duchamp joked and Pollock flung paint, figurative art is about to step into the spotlight and become the "next big thing." Of course, nothing in the art world is a done deal, but when an alpha-dealer (Larry Gagosian) and an alpha-curator (Jeffrey Deitch) come together to "collaborate" on a show of figurative art called *UNREALISM* for Art Basel Miami, the tea leaves are there for all of us to read, and the reactions are starting to roll in.

Predictably, not everyone is happy.

Apparently the imminent rise of figuration has enough momentum that specu-collector/dealer Stefan Simchowitz felt the need to post this sarcasm-laced warning on his Facebook page over the weekend:

> *I love this new trend of figurative painting now. I mean, what a bunch of baloney media, collector driven pivoting, in reaction of Walter Robinson's utterly inane Zombie Abstraction, pseudo analysis of the state of the art. Well, every idiot who sidelines as a collector is after a painting with a figure in it. The circus has a new act, till the next intermission, and Miami will be that next act.*

Simchowitz has a point: art world fashions can fade quickly, but I would argue that figuration, with its very, very deep roots, may be rested and ready to surprise all of us. Schools like the New York Academy of Art and numerous ateliers have been graduating some extraordinarily skilled students in the past few decades and they (and their professors) are on the rise. Keep in mind though, there is a really, really broad range of what one might call "figurative" or "representational" art, and the news release for *UNREALISM* on the Gagosian website makes it clear that "academic" figuration will not be part of the mix Miami:

The artists featured in UNREALISM work within the figurative canon without becoming academic.

Really? There is nothing "academic" about the work of John Currin, whose *Rachel in the Garden* appeared along with the *New York Times* article? His work also appeared this May on the cover of *Fine Art Connoisseur*, which is the blue blazer "conservative" foil to *ArtForum*. Don't tell me there isn't some weird convergence in the air...

Speaking of magazines, it should be noted that the most widely read art magazine in the United States is *Juxtapoz*—which features a range of representation from "Lowbrow" to Odd Nerdrum—with a circulation of 127,000, more than twice that of *ArtForum*. Add to that, *Jutapoz's* star attraction—Mark Ryden, the "Prince of Lowbrow," stands poised to burst past the gatekeepers and enter major museum collections soon.

The title of the Gagosian/Deitch show—*UNREALISM*—(yes, all in emphatic caps), reinforces a point that I made in a blog posted in

January of 2015, that unadulterated Realism—which is not seen as avant-garde, remains taboo. I also pointed out that there are certain "credentials" that can help artists avoid the onus or being labeled a realist:

> *Outsider status can work, as can a reliance on subject matter that is "deconstructed" in relation to social, sexual and political issues. Perversity is good, and so are self-conscious strangeness, obsessiveness, and irony. Warholian strategies involving mechanical and technological methods of image making are helpful. Conceptualism, which I think mixes with representation very lamely, can also get you in the front door of the avant-garde academy. Sadly, a connection to wealth and/or celebrity can work too.*

Currin's work is apparently "perverse" enough to be blue chip, but it is also "skilled" enough for *Fine Art Connoisseur*. I find that confusing, in a good way. Looking over the list of 50 artists included in *UNREALISM* is a perplexing experience (what is Urs Fischer doing in the show?) but the confusion is perhaps understandable since the show was obviously culled from pre-credentialed, mid-career or better gallery favorites. There are, as you likely know, scores of galleries and artists who have already been showing figurative art that has generated the "buzz" underneath this development, and it goes without saying that some of the very best figurative artists around won't be represented in *UNREALISM*.

In the future, things could be quite different...

Calling yourself a "representational" or "figurative" artist right now is rather like identifying yourself as a "Christian" or a "Muslim." In other words, what those terms mean is so broad that they seem to serve as mere covers for an impossibly broad range of ideas and values. What you make on your easel will have to be your actual statement of values. Even if you are a "realist," and you feel carefully screened out of *UNREALISM*, the rising tide of figuration may already be starting to float your boat. Maybe you won't have to sit at the fuddy-duddy table forever.

What in fact may be happening is that the top of the art market is beginning to figure out what the blogosphere has been saying for some

time: there is a new respect for skill—another very broad term—and a hunger for imagery. Now the market just has to figure out that there is also a hunger for authenticity and sincerity, but I'm not holding my breath on that count. Whatever happens, figuration, representation—whatever you want to call it—is going to be hybridizing itself into some unexpectedly wonderful art in the coming years.

"I've seen a lot of prejudice against representational art since I began my career," says L.A. artist F. Scott Hess. "I would say that in the last 40 years it has never been better than it is now. We have made representational art for 40 thousand years. Gagosian is getting on the bandwagon a little late."

Originally published in The Huffington Post, November 30, 2015

ON ART AND EMPATHY

Käthe Kollwitz, The Grieving Parents

It is my duty to voice the sufferings of people, the sufferings that never end and are as big as mountains.
— Käthe Kollwitz

The great German artist, printmaker and sculptor Käthe Kollwitz (1867-1945) knew profound personal suffering. After her younger son Peter died in battle in Flanders in October, 1914 she fell into a deep depression that re-shaped both her art and political views. The double

sculpture that she finally completed in 1931 for the cemetery in which her son was buried shows the artist and her husband apparently kneeling in grief. However, when asked about the sculpture's theme, Kollwitz explained that it was about much more than grief: it also represented all parents of her generation, asking forgiveness for having led their sons into war.

The Grieving Parents, like so many of Kollwitz's finest works, is grounded in empathy: the ability to understand and share the feelings of another. Kollwitz recognized that she was expressing something greater than her own feelings and that her art could only function if it served an entire society. Grief and loss are universal feelings that bind us, and sharing them with others leads to consolation and social transformation. It is not surprising that in 1936 the Nazi party barred Kollwitz from displaying her works and branded them as "degenerate." Deep feelings for the sufferings and losses of others—which lead to collective introspection—can lead to resistance against authoritarian politicians and those who advocate war and other forms of sacrifice and suffering.

It is interesting to note that the idea of empathy is a late-nineteenth/early twentieth century development that derives from the imaginative act of projecting oneself into a work of art. In her book *You Must Change Your Life: The Story of Rainer Maria Rilke and Auguste Rodin,* author Rachel Corbett writes:

> *The invention of empathy corresponds to many of the climactic shifts in the art, philosophy and psychology of fin-de-siècle Europe, and it changed the way artists thought about their work and the way observers related to it for generations to come.*

The development of empathy as a social expectation and custom parallels the development of Expressionism and of inwardness as a gateway to emotional connection. That inwardness—so essential in the modern conception of a self-aware individual—is the hinge that connects to social awareness and the empathetic understanding of others.

Empathy is, without doubt, a political force that plays a consider-

able role in attitudes towards social issues. In a recent article for Psychology Today—Beware: America's Shocking Loss of Empathy—attorney and social advocate David Noise argues that empathy and it's "cousin" compassion are crucial elements in politics and policy, arguing that they "lead to an intelligent assessment of what is happening internally and around the world, a minimal level of humane values, and rational attempts to apply those values."

In the context of America's recent presidential election, where outrage, uncivil discourse and personal attacks demonstrated a shocking lack of empathy, it seems critical for artists to ask themselves about the role of empathy in their own work. Whether their work is political, personal or somewhere in-between, the element of empathy can allow an artist to "give voice to the sufferings of others," as Käthe Kollwitz did so nobly in her works.

What Artists Have to Say About Empathy

Steven Holmes:

Making art assumes empathy. Making art is an act of sharing. It is by definition, an invitation to others to leave their isolation and meet others on the same road as you. An artist without empathy is a sociopath.

Mark David Lloyd:

Empathy can be painful. When we witness suffering and distress in others, our natural tendency to empathize can bring us vicarious pain.

Isaias Sandoval-Streufert:

For me empathy is essential. Without empathy it will be only apathy. My work is about passion; I can't paint apathy even if I try.

Nancy Good:

Empathy is key as it speaks the language of connection, i.e. connection to the life experiences of the viewer. We are all connected in pain, joy, fear, wonder, hunger, and yearning. Empathy in art banishes isolation and invites healing.

Franck De Las Mercedes:

Most of my work stems from an emotionally charged, at times dark, at times painful place. To hear others regard it as beautiful or meaningful to their lives is the biggest compliment. The gift is in sharing and understanding the feelings and experiences of another.

Judith Peck:

In order to create, I have to feel very deeply. Without that connection I believe my work would be a hollow shell.

Steph Rocknak:

Great artists have always seemed to know what the enlightenment philosopher David Hume (1711-1776) knew. They hook us up to the empathy machine when we become too self-involved, too isolated. For the most part, artists, not philosophers, keep us human. They can put us—no, sometimes force us—into the other person's shoes.

Dab Zabooty:

Without empathy art becomes a technical exercise.

Joseph Bravo:

Genuine aesthetic communication rests on empathy between the artist and the viewer.

Vonn Sumner:

Empathy is the most important, most essential, most foundational element of

painting and drawing. Empathy was the guiding principle of Wayne Thiebaud's teaching, and he would often state it plainly. He would also say that empathy is the basis of civilization and quote Gloria Steinem: "Empathy is the most radical human emotion."

Joao de Brito:

Here is a Portuguese Proverb: "O artista é a voz do povo" (Artists are the voice of the people.) In other words, artists can channel empathy to express what needs to be seen or heard by the public when the world is in confusion.

Ingrid Reeve:

My art is not about progress; it's about truth. Empathy is essential for discerning truth.

Originally published in The Huffington Post, January 15, 2017

BO BARTLETT: THE INTERMEDIARY

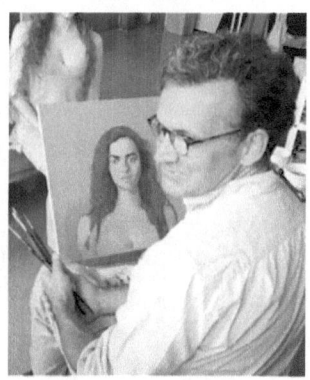

Bo Bartlett

In early 1991, art critic Roberta Smith looked over Bo Bartlett's painting *God*—a striking image of a black man poised in front of a sweeping coastal horizon, wrapped in a quilt—and came slightly unglued. In her New York Times review of the exhibition she later wrote of the piece: "As consciousness raising, this is fairly simple-minded. As history painting, it's idiotic."

In the same column, Smith also dinged Bartlett for his "conservative" artistic style (realism), and dismissed his paintings as being "more

trendy than timeless." Smith's comments, which generated a domino effect of subsequent negative reviews—by Peter Schjeldahl, Michael Kimmelman and others—re-shaped the arc of Bartlett's career.

"The Smith review was devastating for me," Bartlett reflects: "Some sales dropped away: two reviews and an article in a major art magazine strangely evaporated. I withdrew into myself more and painted exactly what I wanted to paint more and essentially said: 'F-all y'all.'"

In the years that followed, his close friendship with Andrew Wyeth —a mentor figure that encouraged Bartlett to persevere—and his personal commitment to authenticity helped form the "thicker skin" that protected him as he re-booted his career. Over the long haul, Smith's three paragraphs had the effect of turning Bartlett further inward, something he has come to value.

"In some ways I'm grateful to Roberta Smith for the review," Bartlett says now, twenty-five years later. "I had the opportunity to mention this to Roberta a couple of summers ago when we met in Maine. I don't think she even remembered writing the review, and when I reminded her of its contents—i.e. 'idiotic'—she said, 'that's a horrible thing to say.'" It was, but as Bartlett well understands: "We believe what we read in the New York Times."

Bartlett isn't the only notable realist painter to be treated like a fly and swatted off the coffee table book of ART by east coast critics in the past few decades, but it was still a pretty lonely situation. Fortunately, the more atomized art world of 2016 supports and celebrates a broader range of tastes. Traditional critics and downsized newspapers now hold less influence and the fast-evolving blogosphere supports affinity groups for every kind of art. In the now thriving circle of Contemporary Realism (a necessarily vague title for a set of approaches too varied to name) Bartlett looks more and more prescient: a model of commitment who took some knocks, kept his head down and stayed true to his inner vision.

"I was in the thrall of Bo Bartlett the first time I saw his work at the New York Academy of Art," says artist Graydon Parrish. "From then on, when I need a sabbatical from the machinations of the Art World, I seek out Bartlett's world to reset my soul." What Bartlett's

early detractors likely missed—and still often miss—is that his work functions without the slightest trace of fashionable irony: he and his art are of one piece. Bartlett is earnest—sometimes painfully so—and that has created its share of misunderstandings, possibly including Roberta Smith's sharp reaction to his work.

Being earnest—a lingering art world taboo—is part of what makes Bartlett "different," especially because the content of his work deals with American culture, which he sees as suitable for mythologizing, straight-up, including its deeply embedded optimism. Like his mentor Andrew Wyeth, Bartlett is a realist-savant, a kind of medium who lets his material come through into paintings that look real, but which are in some respects waking dreams.

Yes, Bartlett has been influenced by American realists—including Eakins, Wyeth and Homer—but his work also shares hints of the dreamlike solemnity found in the works of the European masters Balthus and Dali. Bartlett's best paintings are trapdoors that lead from perceived experience into the mystical, the mythological and the enigmatic. He is an artist-as-intermediary who serves as a guide and then walks away to let you feel the magic—if you can—to the point that you can be present enough to enter and empathize with his characters and their situations.

For example, Bartlett's Heartland series includes a painting of a gun-toting young hunter and his love leaning on a Chevy pickup, which displays a newly shot deer on its roof. In the foreground a boy holds a stick that aspires to be a rifle. Just how does Bartlett feel about this trio and how does he want you to feel? If he has opened the scene up enough so that you can "enter" it without judgment, you are on the right track. Bartlett's canvases are vignettes from an ever-evolving quilt of America and American-ness. His life project is to be an agent of positive change; to try and keep the American fabric whole by making its realities evanesce and coalesce into fresh myths.

A politically progressive painter born and raised in a conservative southern state (Georgia), Bartlett has always believed in the power of art to ameliorate differences and unify opposing ideas. To see it otherwise is to feign sophistication as a cover for cynicism:

I believe in the power of Art to transform lives. My hope is to find connective tissue between opposing ideas to try to help find common ground, to show that we are all in this together. If we can move beyond the cynicism, the dualistic thinking, all the rhetoric and posturing, if we can listen to others, reach out and find the things we have in common with others we'll start to resolve some of these conflicts that appear irreconcilable. I've seen Republicans and Democrats, the wealthy and the homeless, people of all races and genders, standing shoulder-to-shoulder appreciating the wonder of a work of Art.

This personal interest in bridging gaps—of being an intermediary—is the main motivation behind Bartlett's recent *Lacunae Series*. Their imagery, which Bartlett describes as "mashed-up," was inspired by both historical contexts and religious traditions.

John Seed Interviews Bo Bartlett

JS: What are the Lacunae paintings about?

BB: The Lacunae address pertinent issues of importance in the culture wars. The other paintings with similarly paired themes are *Galilee, The Samaritans, Christmas, The American, Halloween, The Promised Land* and *Oligarchy*.

JS: Can you walk me through one of the paintings? Tell me about *Easter*.

BB: In *Easter* (also titled *Easter Egg Hunt in the Cemetery of the Confederate Dead*), the Christian story of the resurrection is mashed-up with the Southern phrase "We will rise again." Living in the South, both of these points of view are still alive and well. Healthy fodder should come from our surroundings. The Cemetery of the Confederate Dead is beside my studio. A Dixie flag flies over the rows of white grave markers.

BB: The painting unfolded during the ongoing battle about Southern State Houses flying the Confederate flag. Sen. Alfred Iverson is famous for his memorable post-war cry "We Will Rise Again." Iverson is buried in the cemetery. His son was a debonair General who was largely responsible for Southern troops losing the battles of Anti-

etam, Gettysburg, and he was in charge of troops when Sherman drove through Georgia to the sea.

JS: What about *Oligarchy*?

BB: Oligarchy started with the subtitle *The Sadducees*. The Sadducees and Pharisees were the ruling elite in Palestine in the 1st Century BC and AD. They were often the ire of Jesus's teachings. The Sadducees were in charge of political and religious affairs. They maintained relations with Rome and were in charge of military affairs.

JS: Was there an individual or incident that inspired this painting?

BB: One time, in the early 1990's when I was painting a portrait of Ambassador Walter Annenberg (I used to paint a lot of portraits in Pennsylvania when I was younger), I was painting him in his office, a red phone behind his desk rang, and he informed me that he had to stop posing for a minute and take this call. He spoke in hushed tones, saying, "No, don't do that" and "Yes, do that."

Hanging up the phone and turning back around he informed me that he was advising the President. I asked him about his politics, did he support Republicans or Democrats, he quickly waved his hand back and forth saying "Republicans Democrats apples oranges, that's not where the power is!" And I realized in moment that there is a "They" and that I was in the presence of one.

JS: So the painting is about a very specific group of individuals?

BB: The oligarchy today is the corporate elite: those who profit at the expense of others. The one percent.

The painting took a couple of years of planning and another year to complete. I did drawings and paintings and studies of the primary characters. My friend, a doctor from my hometown of Columbus Georgia agreed to pose for the king. Students from Columbus State University College of the Arts posed for the crowd of figures below. I want it to feel like we aren't certain if they are holding him up saying "long live the king" or if they are carrying him over the ridge chanting "Off with his head" to throw him off the cliff.

JS: Is there more context? What about the figures who surround the Oligarch?

BB: Ferguson erupted while I was working on the painting. The *Black Lives Matter* movement informed the mood, but I didn't want the

painting to represent one particular revolt. The struggles are eternal. The power struggle is eternal.

There are right and wrong sides of history. When we realize that protecting our status can hold us back and create a kind of dead document of our lives then we will live not just for ourselves but also for the wellbeing of others, the other, those who we share this planet with. We live in a holistic system, and everything affects everything else. What I do affects you, what you do affects me. Race, class, gender, these are issues of the day.

The haves and the have-nots, the 1% and the 99%. I'm not moralizing. The work isn't didactic. It's not "history painting" in that sort of way. It is just presenting the situation. The protagonists share the stage.

JS: Is it fair to say that there is a new "darkness" in this work: a new sense of complaint?

BB: I'm not "anti" and I'm not a "stick it to the man" complainer. I believe in working with what's there, not tearing it all down. Perhaps you can see that in the choices in my Art.

I use convention. I welcome cliché as readily as I welcome original thought. Low and high, populist and esoteric: it's all good. I want to build upon what has come before; history is a cornerstone, our foundation. Evolution is incremental, not biological evolution, but psychological evolution. The only way to evolve is through understanding the big picture. Understanding the other through empathy: art engenders empathy. It can transform us. Art is freedom, real freedom.

JS: What motivates you as an artist?

BB: Since reading Suzi Gablik's *The Re-Enchantment of Art* in the early 90s I have grappled with how to meld the challenges she put forth with a sustained artistic practice. I have continued to paint. But my practice has expanded to include teaching school children, working with the homeless, teaching them to paint to express themselves, to tell their stories. Joseph Campbell once said "the artists are the prophets." If that is true, we all have to work harder to be agents of change; to make the world a better place.

Originally published in The Huffington Post, June 18, 2016

MARGARET BOWLAND: THEY SAY IT'S WONDERFUL

Margaret Bowland

Artist Margaret Bowland often deals with issues that are common concerns of postmodernism, including race and identity, but her technique comes from a much older source: the deep tradition of European representation. Bowland is searching for beauty: an eternal quality she feels has been diminished and re-defined by consumer culture. Bowland's works seek out difficult truths, evoking awe and discomfort as the artist's perceptions challenge and deepen our own. She understands that art has the power to let both her models and viewers "exist apart" from the world's limits.

John Seed Interviews Margaret Bowland

JS: Tell me about growing up in North Carolina and how it shaped you.

MB: I grew up in a North Carolina that no longer exists. Pre-internet, small towns were kingdoms. Burlington, NC, the town of my birth was totally self-contained. We were taken as children to Greensboro, to Raleigh or Chapel Hill as my own children have experienced going to London or Paris. Books were my only link to a larger world. I found solace in knowing that others were asking the same questions that consumed me.

Everyone attended a church in my hometown. As a small child I thought when an adult referred to "various religions" he or she was speaking of Protestant sects, Methodist, Baptist, etc. And I was taught to vaguely fear Catholicism. My family's social life was created by its submersion in family and the Baptist Church. From very early childhood I knew that there was something wrong with me.

Sitting in church, three times a week, I believed what others were telling me, that God was speaking to them. But I knew that He never spoke to me. I had no idea why. I prayed nightly and listened, straining in the dark, but there was only silence. So I began to lie about it. There were times in the life of a Baptist child in which you were expected to "testify" that Jesus was in your heart. I did as I was told, all the while knowing myself to be a fraud. This self-knowledge, this great shame, created me.

JS: At the University of North Carolina you studied both Art and English. Why did Art win out?

MB: When attending the University of North Carolina at Chapel Hill I wavered for years between declaring a major in art or one in English lit. I decided to throw in my lot with the English department. I was in total despair within the art department. This finally led to my dropping out of college altogether.

I had arrived at Chapel Hill, which is just 30 minutes from my hometown, like a kid today arrives in NY City from Iowa. Everything was dazzling, sophisticated, and terrifying. Here, I believed I would

find the answers to so many of my questions. Here, I would be taught to paint like the great artists I had seen in books. But of course, I was walking into college in the early 70's and none of what I wished to learn was for offer in the art department of that time.

I was living in a time that celebrated "freedom." Yet, in the art department I found there to be one way and one way only. The teachers were all Abstract Expressionist men from Chicago. When I met them they had warily begun to move from Rothko to Frank Stella. The largest conversation was whether to let the lines you made on the canvas bleed or not; whether to leave the masking tape you were using to create those lines breathe a bit at their edges or fix them hard and fast with acrylic medium. I was told firmly there was no painting of the figure.

I entered a life drawing class where before us stood a naked young woman. Our instructor told us to "draw the fourth dimension." I was 17 years old. My despair and confusion shook me. I painted abstract paintings along with everyone else. I felt exactly like I had in the Baptist Church. I was back in a religion that held no answers for me, that dismissed my questions. Again I was a fraud. But the depression at times would flare up as anger.

I enrolled in a sculpture class to learn how to sculpt. The teacher regaled us the first day with a hilarious story of how he had gotten into the master's degree program at the Art Institute of Chicago. He and a friend had dropped acid and gone all over the city of Chicago throwing chains over objects, over tree limbs, etc. The pal had photographed these works of art. These photos had comprised his portfolio and gained him entrance into one of the most respected art schools in the country. He thought it all "a gas." I said nothing but I began to feel anger. Who was the real fraud in this case?

I made the sculpture teacher a huge magnolia pod of felt that I sewed and affixed to a chicken wire base. I lined the pods with pink satin and he absolutely loved it. Each seed could be pulled from its own vagina of pink satin and pushed back within. The seeds were the size of a child's hand. His euphoria over the piece deeply confused me. I had liked making the pod. I liked replicating it. But these instincts I believed were relegated to just playing with crafts.

The works I had glimpsed in museums were getting further and further away. In the English department the big questions were being asked. How to deal with death without the solace of God? How to define meaning? Here I discovered many writers, among them James Baldwin. His life experience, coming as it did from such a rigid religious background was one I understood. This brilliant man was writing from exile. His doubts and downright disbelief were written there on the page.

Back in the art department, it felt to me there were no conversations of importance. Teachers wafted in and out of classes, often only staying for an hour of a three-hour class. At critiques I was totally lost. I could fathom no continuity in the values and judgments of the teachers and they did not pretend to have one. Frankly, it broke my heart. So I ran.

JS: You have been a realist for your entire career. Since postmodernism has been dominant for the past decades, have you felt your career has a contrarian aspect?

MB: Yes, I have spent my entire life as a "contrarian", but I never for one moment wished to be. I have sought all of my life to be in a community, to feel like others feel, think like they think. But as in a line said by a character in Saul Bellow's *Augie March*, "The soul wants what the soul wants."

My parents could never understand why I could not believe in God, as my college professors could not understand why I could not embrace their new religion of Abstract Expressionism. Now the current orthodoxy is Post Modernism, and I have had the predictable results. I stand in line anxious to receive my glass of Kool-Aid, but when it is in my hands I find that I cannot swallow, even though if I could, rewards might be mine.

Art in my lifetime has been as doctrinaire as any church I have ever encountered. There are things "one cannot do" and these seem to be the things to which I am attracted. I have been told by current artists that the very way that I paint marks me as unsophisticated, backward. One can paint the figure now, but only in a somewhat careless way, or in a cartoon-like format. It reminds me of the humor of Wes Anderson, Bill Murray. You can tell the story but only insofar as you are

signaling to us that you are simultaneously aware that storytelling is an ironic exercise.

The paintings I make are what come to me. They are born of my searching through this world for a belief system. I paint what my psyche tells me to paint and what my eye perceives to be beautiful. I am not coy and I realize, profoundly, that this is a problem for many artists in these times.

JS: You have said that beauty only makes sense to you when it "falls from grace." Tell me how this applies in one painting you have done?

MB: I have made that statement. A more accurate statement would be that beauty makes sense to me when it has suffered damage—therefore entering the world—yet has held on to a sense of itself. That is a shocking accomplishment in a world that distrusts all shared beliefs. Beauty no longer exists as an ideal. The word has fallen to the level of a description of pretty girls and boys attired in expensive clothes.

I look at a model I have used for years, Klare Potter. She is a preposterously beautiful woman by any standards. Fair, long legged, tall, perfectly proportioned. But an extreme case of Alopecia has left her with no hair on her body at all. In the Metropolitan Museum of Art I saw a statue of the goddess Isis. She also had no hair. The Egyptian royalty are thought to have suffered from hair loss as a side effect of inbreeding. Looking at Isis, covered in white paint over the terra cotta, I saw Klare. I covered her in white paint and placed her in a bathtub.

I wanted the viewer to see the woman beneath the paint, the real woman beneath the goddess as the paint loosed from her body in the water. I see Klare as more beautiful now than I believed her to be when she had a head full of blond hair. Now her beauty holds a question. The flaw, the loss, underscores the perfection of what remains. I am painting her again now.

JS: How and why did you begin your *Anna* series?

MB: I began the *Anna* series like I have every series in my life, by meeting the model. Anna appeared one day at the bus stop on the corner of my street and I asked her if she would model for me and she said yes. Our lives then began to entwine. I have been out in the world with her, at restaurants and bars. I am 5 foot 10. So the two of us get

our share of glances. Anna always acts as if she does not notice. But when we are alone I have heard stories, of course. Anna lives defiantly. She has suffered extensively by existing outside the norm, but she has triumphed.

When painting Anna I had never asked her to pose for me nude, as she had seen me paint other models. One day she asked me why. Did I think she was not as beautiful? Heart in throat I said, "No, of course not. I just did not think that I dared." She disrobed. She wanted to be seen through the idealizing medium of oil paint.

Now we look at historical portraiture and see within it only the trappings of the rich and powerful. As modern artists we rummage through these trappings and symbols as through a sack of old costumes. We see in the paintings of Van Dyck, the imperial victory of capitalism and we walk away. We know better. Capitalism has been found out. It is both the monster and the master.

But what of the beauty within a Van Dyck? What of the validation, of the immortality that Van Dyck bestowed upon his subjects? You stand before his paintings of golden haired brothers, attired in satins and read below that both were killed in battle just after the painting was completed. You think of their final scene, of the mud and the blood. Yet that reality does not render the portrait before you a sham. Both are true. Anna wanted to live within this paradox. She wanted to feel that lifting off. She wanted to stand before a painting done by me of her and see herself through my eyes and as such, through the eyes of the world. She wanted to exist apart as art allows one to do.

JS: Have you ever been told that as a white woman you were wrong to paint African Americans?

MB: Yes, I have often been told this; but rarely by African Americans. And this taboo certainly does not hold true in other art forms. For decades white authors and filmmakers have made films and written books about African Americans.

I feel I have the right to paint African Americans because out history is combined. I grew up in a segregated South. I grew up in a world of signs on doors and water fountains that said "White" and "Colored." Children know in their bones when they are in the midst of injustice. They experience the nausea that comes from the realization

that the adults are not to be trusted. They grow up in a world of shame from which there is no departing.

Again, in a quote from Saul Bellow, I see the facts of this. He says "Repression is not precise. You repress one thing; you repress the thing adjacent." The white adults who raised me had no idea of what they were paying through the repression of their souls by the world order in which they lived. But damage was done.

The inclusion of more voices in art has certainly been a wonderful thing. As a woman, I am one of the voices that was not heard in the past. All of my life people have approached me and declared, "You paint like a man!" And all of my life I have flinched but realized that this, from the speaker, had been meant as the highest compliment. It is the obvious and correct statement, after all, to ascribe to a painter who has spent her entire life looking and trying to learn how to paint from men. I never thought of it in that way, not once. I simply wanted to learn what they had known so that I could try to create my own worlds as they had

I find it depressing when artists who are not white males say that they have nothing to learn from these old dead guys. Well, there is an inherent problem here. The very language they speak—the images they see—have for the most part been created by males. Throwing away the accomplishments of these men is not possible. If you are a feminist filmmaker you are using machinery created by men, and the very concepts you are employing to tell the story were created by men.

"Isms" are not my thing. There is always at the heart of any political act a simplifying, a cutting away of the very details I find most interesting. Often political units feel to me like desperate attempts to find a center again, but sadly, this center is not one of intellectual unity but only a grab for power. I do not see change, only the replacing of one despot by another.

I teach at The New York Academy of Art in NY. It is solely a graduate school so the students we have are facing the hard facts of the marketplace upon graduation. In the hall I heard two of my students discussing a third. They said, exasperated, "How can we be expected to compete with her? She was born poor, if white, in a trailer in NC. She was raised by a single mother after her father became mentally ill."

What stunned me was that the student to which they were referring was indeed a threat to them. She was one of the most talented students that I had ever had, but her work was never even mentioned. It was her story that frightened them. The personal story has often now become the Art. Art is not about creating something. It has become a lifestyle choice. One decides to be an artist and then whatever follows is art.

There are many artists whose work places them way above the pettiness of these facts. I was teaching from the art of Mickalene Thomas one day. I had showed images of hers to show the students about the ways space could be manipulated in the hands of a great artist. Thomas had led us into a perspectival space only to leave us circling back upon ourselves like in De Chirico. Unlike his nightmare colors of grays and browns, Thomas had lit her world with lime green and pink. She had scored her moldings with glitter. All to show us that what we believe we can enter we cannot. She shows us how easily we can be seduced by gorgeous color into entering a world that wakes us up. The class and I talked about this work, brought in paintings of Giotto to compare; we talked for nearly an hour.

Mickalene Thomas is an African American lesbian. But not once were these facts necessary in the discussion of her work.

Of course a backstory is of use in the understanding of an artist's work. But it should be small potatoes by comparison to the work itself. After all, the work presumably will one day leave home and have a life of its own without Mom or Dad. Or that remains my hope.

Originally published in The Huffington Post, December 1, 2014

KERRY JAMES MARSHALL: "MASTRY" AT MOCA

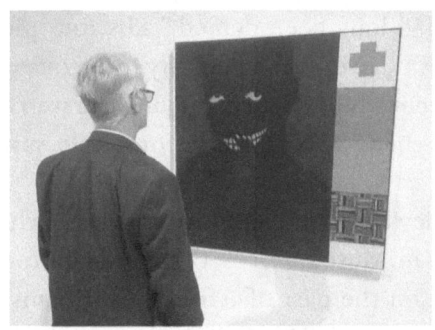

Viewing Kerry James Marshall's Silence is Golden

The idea of joining the continuum of Art History has also been a life-long goal for Kerry James Marshall, who has dedicated his career to addressing the omission of black figures in the Western tradition. "He knew he wanted to be an artist very early in his life," recalls his friend Luis Serrano. " If I remember correctly, he took a field trip to the museum in elementary school, and he told himself he wanted to create works of art and to be collected."

A dedicated student who pored over paintings in museums and books, Marshall was motivated by the gap between what the Old

Masters had been able to do in their art and what he wanted to do in his. His ambition and racial consciousness helped Marshall to come to a pragmatic realization: that "Mastery" is a way of achieving freedom and entering the world (and history) on your own terms. "You have to recover the capacity to imagine yourself as an ideal" Marshall says, "and figure out how to project that into the world."

Marshall's project, which involved idealizing and re-positioning the identity of his race and community, has used the color black as both a formal device and a metaphor. All of Marshall's figures are black—racially and chromatically—which has the effect of making black function in a new and symbolic way. Black never appears in the surroundings of Marshall's figures, but it is serves emphatically as their skin tone and marker of their beauty.

As MOCA's website offers: "By mastering the art of representational and figurative painting during a period when neither was in vogue, Marshall produced a body of work that bestows beauty and dignity where it had long been denied." His four pictures of Boy and Girl Scouts—which have the solemnity of icons—manage to both elevate their subjects while also multiplying the web of social complexities that envelop them: is that a blast or a halo surrounding the Boy Scout's head?

While I was viewing Marshall's retrospective (which was organized by the Metropolitan Museum of Art) the social presence and obvious pride and interest on the part of African Americans visiting the show was moving and profound. Marshall's paintings do for African Americans what the Romantic works in the Louvre's *Salle Mollien* did for the citizens of Post-Revolutionary France, which is to validate and ennoble their passions and struggles.

It must be extraordinary for Marshall to step back and reflect on both his success in making museum-worthy art and in having used his imagination as a tool for cultural transformation: Marshall's level of commitment and social consciousness deserves tremendous respect. Numerous and honors—including a 1997 McArthur Award—have cemented his achievement and brought Marshall's work into the pantheon he once admired as an outsider.

In the process of entering the canon, Marshall has clearly studied

and absorbed ideas and motifs from a wide range of influences including Renaissance art (Giotto is a favorite), Haitian and African art, folk art and also from the works of modern artists including Warhol. Marshall's use of collage elements recalls the work of Jean-Michel Basquiat. His ability to insert cultural references across a single image seems to have inspired references and energies of Marshall's *The Land That Time Forgot*.

One charming reference that I noticed at MOCA was Marshall's re-appropriation of the anamorphic skull in Holbein's 1533 painting *The Ambassadors*: it is transformed in Marshall's 2012 allegory *School of Beauty, School of Culture* into a kind of flattened and skewed Disney princess, perhaps the only white-skinned face to appear in any of the artist's paintings. It's a painting about the intersection and celebration of black beauty and culture, and the anamorphic image of white cartoon glamour serves as a kind of cultural memento mori, a weird apparition that two small children inspect with a mixture of curiosity and caution.

Marshall's most recent paintings radiate the artist's continuing ability to deal with complex themes with candor and confidence. The erotic avidity of the woman reflected in *Untitled (Mirror Girl)* from 2014 is both welcoming and comic while also opening the door to the consideration of the possibilities of self-disclosure in the age of Instagram. The items taped to the mirror's frame—including a dry-cleaning bill and a bank receipt—add a hint of everyday life that grounds the glittering scene in reality.

At the end of my visit, I found myself looking at *Marshall's Silence is Golden*. By doing so, I felt myself taking part in a conversation that Marshall had invited me to join. Thirty-five years earlier my encounters with Jean-Michel Basquiat and his art had shaken me up by showing me the limits of my world. Now Kerry James Marshall and his art were offering me the chance to see more, to see further. I left the exhibition feeling moved and humbled by Marshall's vision. Marshall's exhibition had enriched and expanded my art world, opening up a dialogue that offered me the possibility of understanding.

Originally published in The Huffington Post, April 1, 2017

ABOUT THE AUTHOR

John Seed, at the Broad Museum, Los Angeles, with one of the three part canvases he built for Jean-Michel Basquiat in 1983, April 2019.

John Seed is best known for the over 300 blogs about art and artists he contributed to the HuffingtonPost between 2010 and 2017. Seed has also written about art and artists for Hyperallergic.com, Arts of Asia, International Artist, Harvard Magazine and other fine publications. He is the recipient of a Society of Professional Journalist's award in art and entertainment writing and was featured as a guest expert in the Google Arts and Culture video series "Name that Art."

Front Cover:

John Seed looking at "Ribs, Ribs, Ribs," Photocollage by Photofunia.com

Back Cover:

John Seed at MOCA with Kerry James Marshall's Silence is Golden

Artist Photos:

 [Photographs of artists taken by Mimi Jacobs, photographer], 1971-1981. Archives of American Art, Smithsonian Institution.

ALSO BY JOHN SEED

Arman Manookian: An Armenian Artist in Hawai'i
Artist's Statements of the Old Masters
Disrupted Realism: Paintings for a Distracted World

www.ingramcontent.com/pod-product-compliance
Lightning Source LLC
Chambersburg PA
CBHW021817170526
45157CB00007B/2625